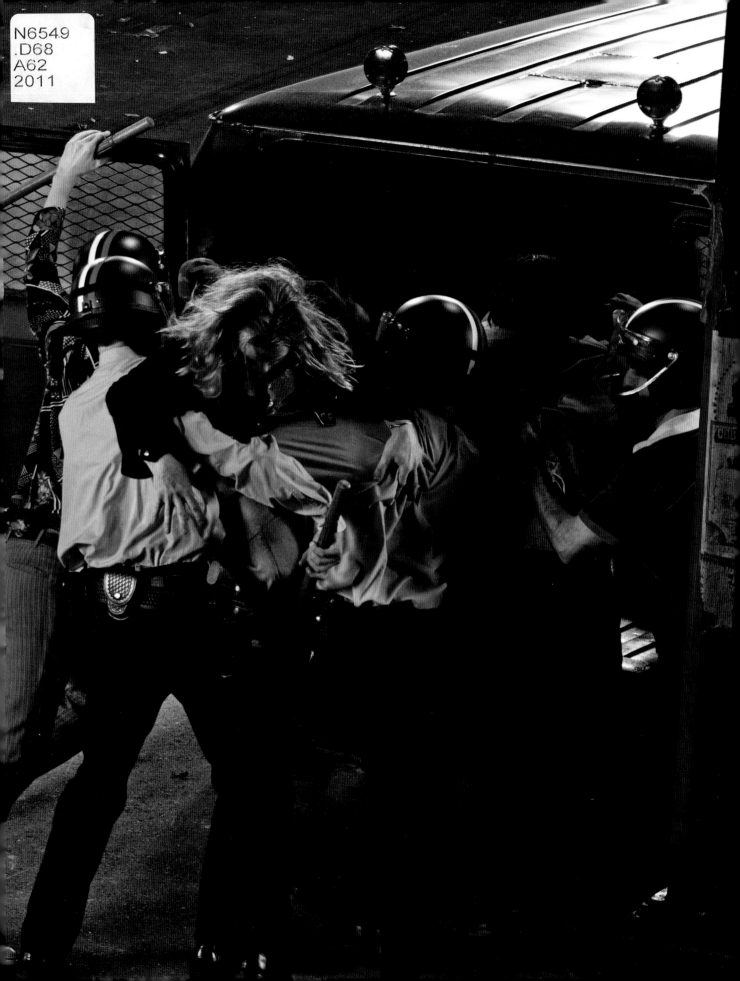

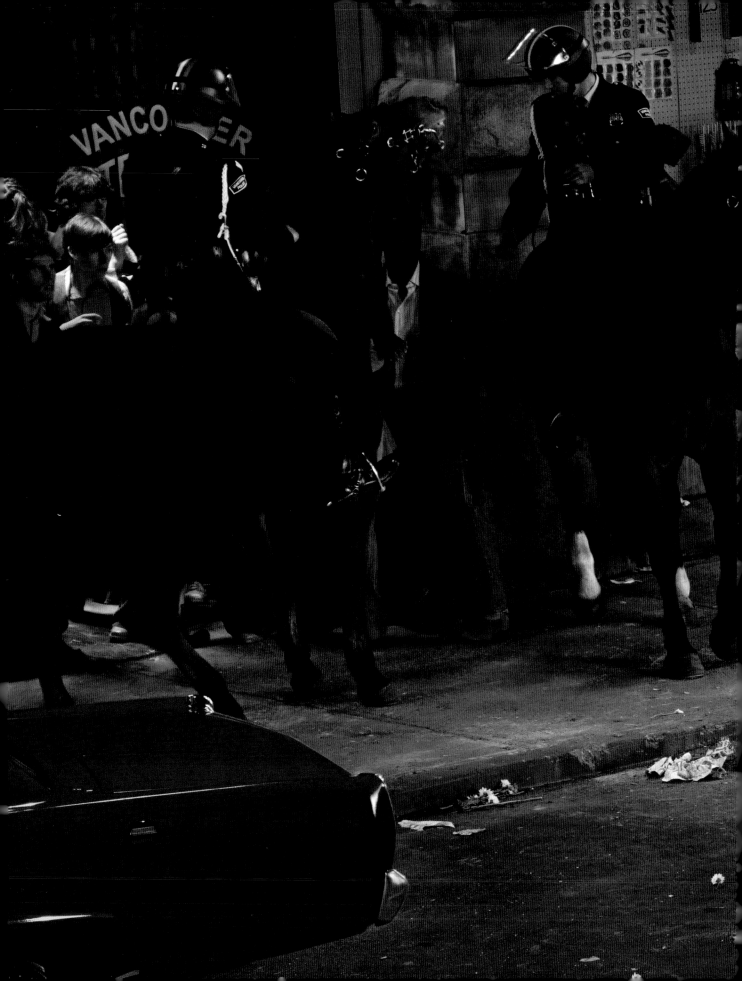

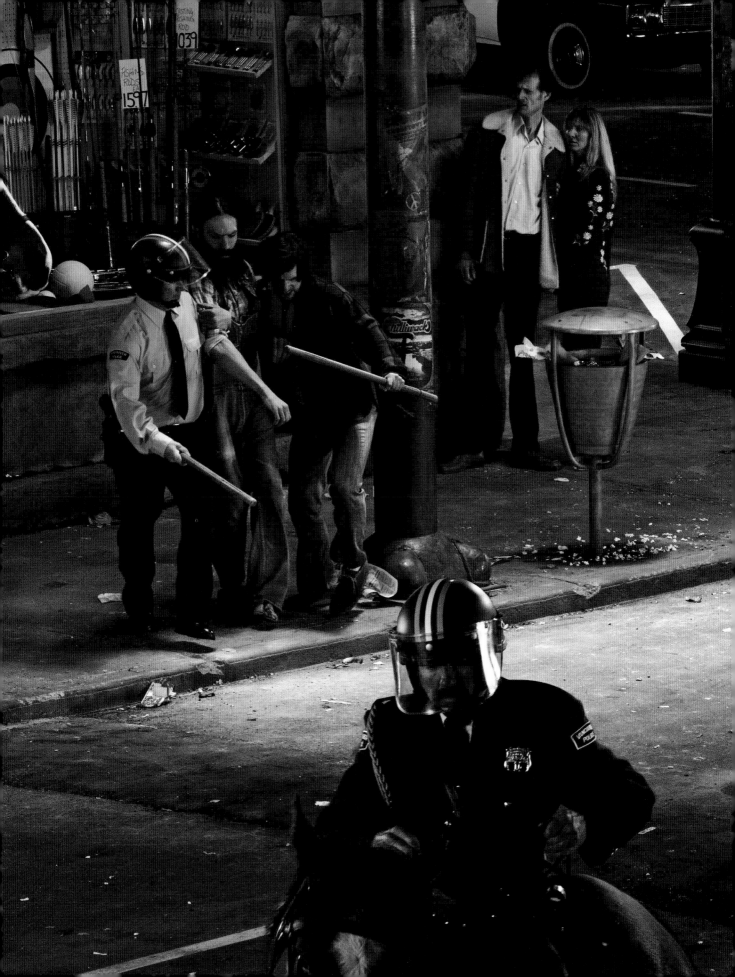

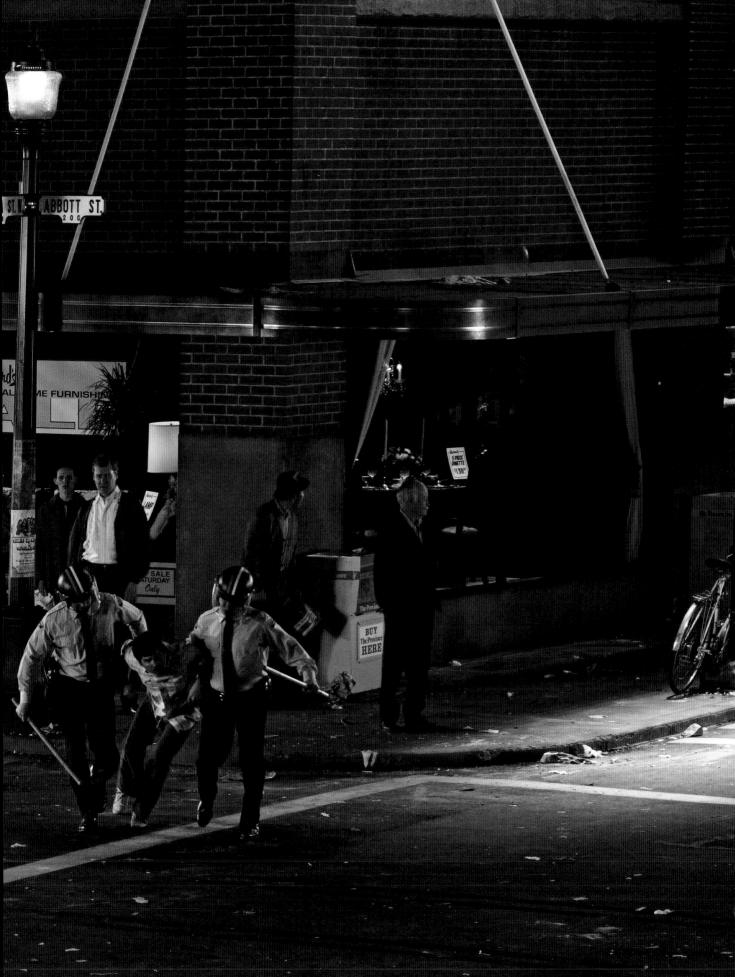

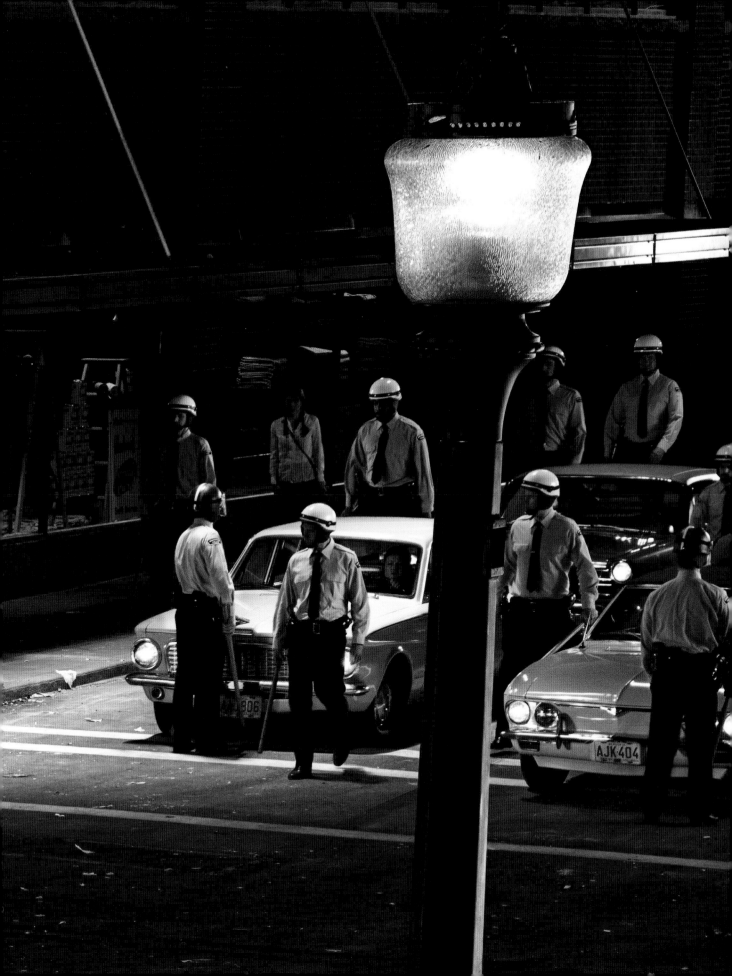

STAN DOUGLAS

Abbott & Cordova, 7 August 1971

Arsenal Pulp Press

Vancouver

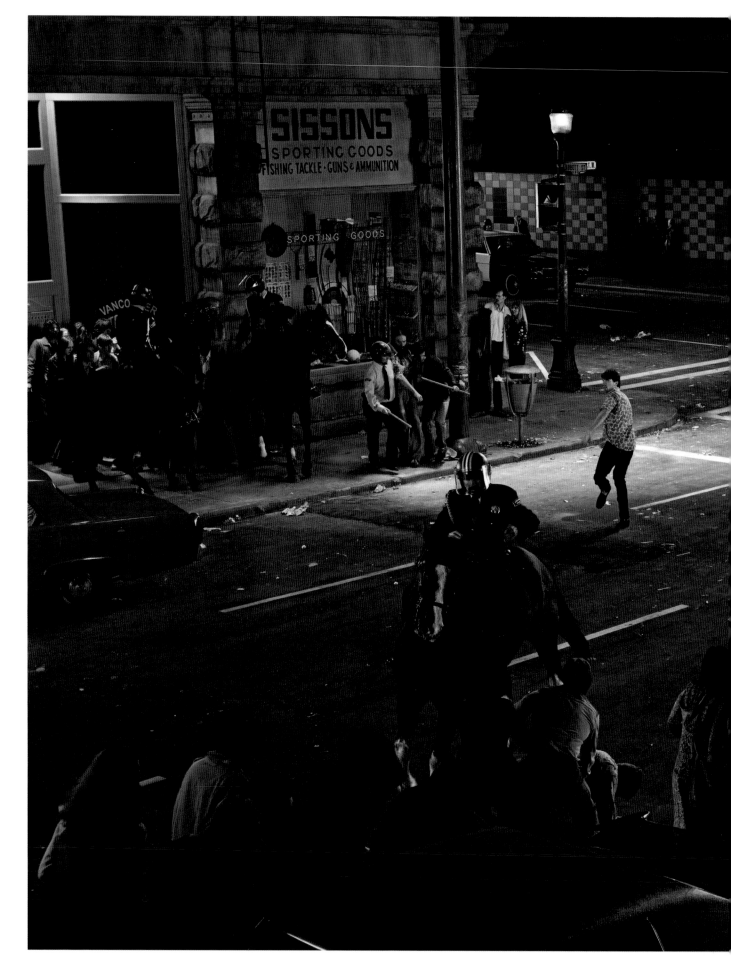

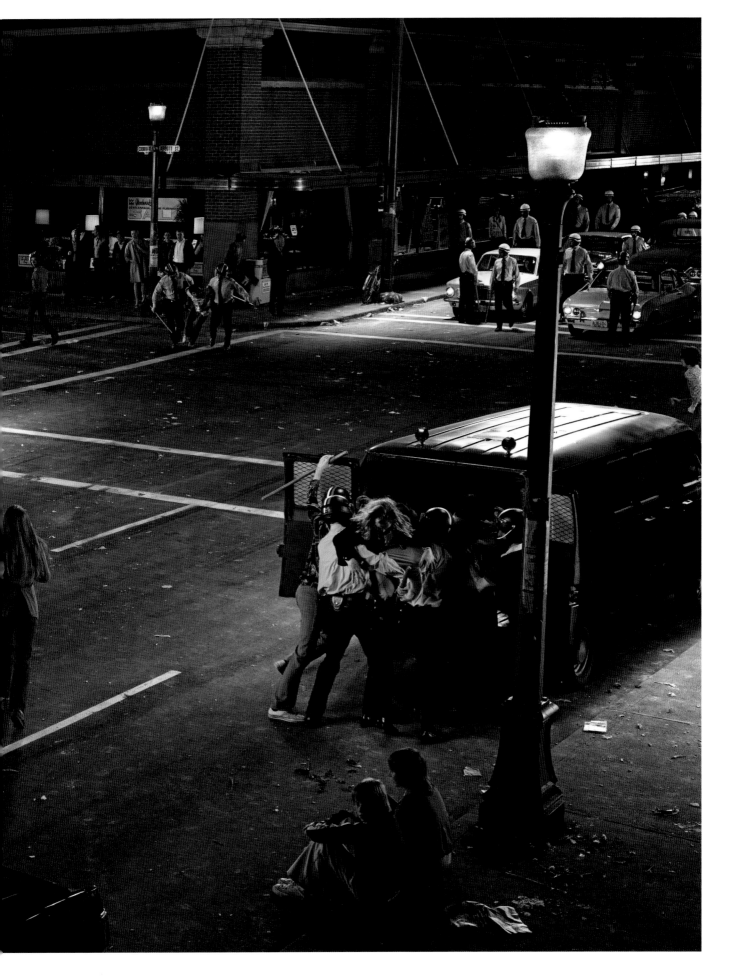

CONTENTS

AN INTERVIEW WITH STAN DOUGLAS

Alexander Alberro

This interview took place on November 25, 2010.

Alexander Alberro What is the event that your photomural *Abbott & Cordova, 7 August 1971* represents?

Stan Douglas It all began as a "smoke-in" at Maple Tree Square in Vancouver's Gastown district, organized by the *Georgia Straight*, the local alternative newspaper. Bands were invited to play music; flowers, popcorn, and watermelon were given away; and at one point a ten-foot papier-mâché joint was paraded around. It was a typical, early 1970s hippie festival. Thousands of people came to take part, and by all accounts were having a peaceful time until 10:00 p.m. when the police arrived and told them to disperse. There were so many people that few heard the [police] chief declare over a megaphone that they had ten minutes to clear out, so few did anything.

It seems that there were a couple of agendas on the part of the police force. Undercover narcotics officers dressed as hippies had mixed with the crowd, seeking to identify drug dealers and what they called "trouble makers." Their aim was to detain these people, to arrest them. Other officers were instructed to clear the streets, which is what they tried to do. This made it difficult for the narcs and for those from the mounted squad, who were trying make people stay put until the paddy wagons arrived. Not surprisingly, the police vans were delayed by the whole street-clearing effort.

When the police charged, people couldn't run north because of the waterfront; they couldn't run east because that's where the cops were; and they couldn't go west because that's where off-duty officers had assembled and had begun to march into the fray (you see them in the upper right-hand corner of the picture wearing white helmets). So when people tried to disperse in the directions we see in the picture—west and south—they were trapped by one segment or another of the police force, and the confusion on the part of the cops precipitated the confusion and panic of the whole event.

AA So the corner that the *Abbott & Cordova, 7 August 1971* mural depicts is on the margins of the epicentre of the event?

SD Exactly, yes. The corner of Abbott and Cordova is one block away from the epicentre. But of course the event became dispersed almost immediately. When the riot squad moved in, everyone began to run. *Abbott & Cordova, 7 August 1971* depicts one of what must have been many micro-events around Gastown that night.

AA The twenty-first century has begun with a lot of street demonstrations that have resulted in clashes with the police. To what extent is your decision to focus on the events of August 7, 1971 driven by these contemporary events?

14

SD I consider the demonstrations against budget cuts that we're seeing in Europe today, or those against the formation of the World Trade Organization a decade ago, or those against the Iraq War in 2003, to be much more serious than what's depicted in *Abbott & Cordova, 7 August 1971*. Relatively speaking, the coming together of people in August of 1971 was a frivolous protest—I mean, protesting the fact that they weren't allowed to smoke pot.

But in a larger sense, what the protest was about was the curtailment of civil liberties. And I think that the large gathering in Gastown that day, as light-minded as it might appear now, was enabled by the large antiwar and civil-rights demonstrations of the 1960s. So just as the events that I've rendered are at the periphery of the epicentre of the riot, the event as a whole was at the periphery of, but nonetheless related to, the mass demonstrations of the 1960s and early 1970s.

AA How did the project initially come about?

SD The conversation was initiated by the architect Gregory Henriquez. He asked if I was interested in doing a work for a project he was designing in North Vancouver. I told him that I would be more interested in doing something for the commission he had in Gastown, at the old Woodward's department store site. Eventually I had discussions with him and the developer, Ian Gillespie, and to my surprise they were very enthusiastic about the idea of making a picture of a riot.

AA Was the project very expensive?

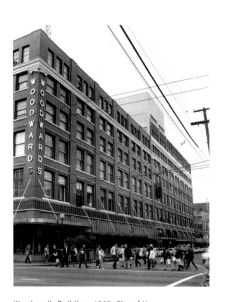

Woodward's Building, 1968. City of Vancouver
Archives, CVA1095-201E3_F8S347F17

SD It was made like a motion picture, like one shot in a major motion picture on a purpose-built location. At first we wanted to work on the original site. But we soon realized that it would be a lot easier, and a lot less expensive, to build the location, which is what we did.

We rented a large parking lot beside the Hastings Park Race Track, laid blacktop for the streets, poured concrete for the sidewalks, installed flats for the two buildings, and then aged everything. We waited for the production of *The Day the Earth Stood Still* to wrap so we could get all the lighting we needed from Paramount Pictures. Freezing the action of people and horses running about an intersection without too much motion blur at the optimal ISO and aperture required 700,000 watts of tungsten light.

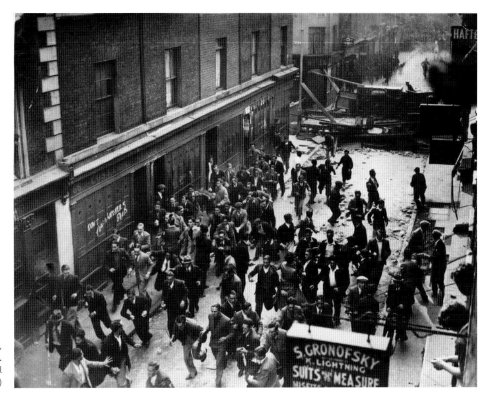

The Battle of Cable Street, London, October 5, 1936. (Photo: David Savill/Topical Press Agency/Getty Images)

Casting performers was a long process. I looked at more than 1,000 head shots and one-sheets, which I organized into groups and categories of people who lived in the area. Then everyone had to be fitted for period costumes, and the performers had to be styled and made-up.

The whole thing was shot over three nights. The nearest part of the scene was shot on the first night, and Abbott Street and beyond on the second. We shot the plates, or backgrounds, on the final night. I devised nine scenes, or general groupings of performers and their interactions, for the first two nights, but of course improvised and modified my direction based on what was happening.

The picture is composed of about fifty discrete images composited together. At first I thought I could shoot the piece on 4 x 5 or 8 x 10 film, and even had a scheme to keep a processing lab open while we were shooting. But after doing some side-by-side comparisons with high-resolution digital backs and lenses, I realized that if I shot digitally there would be less chromatic aberration and better geometric stability. I would also be able to see the frames immediately. I wouldn't have been able to make this photograph as well, or as quickly, using analogue means, and I've shot digitally ever since.

AA Why did you decide that the elevated shot, the elevated placement of the camera, would be the most appropriate for this image?

SD As the idea of making a picture of a riot was coming together, I began to look for some kind of model or precedent, a paradigmatic image. I briefly became fixated

on a photo of the famous Battle of Cable Street that took place in London in 1936. It represents a clash between the Metropolitan Police, overseeing a march by the British Union of Fascists, and anti-fascist groups. But let's not read too much into that. I just liked the way the photo depicted crowd behaviour. At that point I still thought we could work on location and get away with installing a single flat of the Woodward's building. But when it became clear that we were going to build the entire intersection, I started to explore other vantage points and decided to look southwest, toward the corner of the department store.

Stan Douglas, *Monodramas: I'm Not Gary*, 1991. Stills from a video for broadcast television

We made a 3-D model of the location to pre-visualize what the set would look like, and to know what would have to be built. My producer, Arvi Liimatainen, informed me that we couldn't afford to duplicate the Cable Street view because it looked too far down the street. At that moment, the camera was positioned at what would have been a second floor window of the Travellers' Hotel, one of the places where hippies had begun to hang out. I kind of liked that, so I just panned a little to the left and the problem was solved.

AA Clearly *Abbott & Cordova, 7 August 1971* also establishes a relationship with advertising.

SD Certainly. The piece takes the format of a large billboard advertisement, or public service message, close in scale to the huge Kodak backlit transparency that used to hang in New York's Times Square. But it doesn't play by the rules of advertising because it presents content that is obviously non-commercial. Insofar as it disrupts the conventions of a medium with foreign content, the work relates to my earlier *Television Spots* [1988] and *Monodramas* [1991], in which narrative content that one would never normally see during an advertising break was inserted into the flow of broadcast. *Abbott & Cordova* doesn't present a pictorial gestalt typical of billboards, one that can be read quickly from, say, a passing car. Rather, it's meant to be read in bits and pieces because the architecture of the complex very often reveals the image in fragments as one rounds a corner or approaches it from the street.

AA What's at stake for you in this particular event? Do you remember it taking place?

SD No, not really. I don't recall the event. I wasn't there. I only knew about it from hearsay and, I suppose, from a drawing by Vancouver artist Neil Wedman called *Gastown Riot* [1998], which has a completely different take on the riot. I never got into it in-depth until I began to do some research. But keep in mind that I've been loitering in this neighbourhood for most of my adult life. I've rented studios in and around Gastown, and frequented shops and bars here for years. Today my studio is three blocks east of Abbott and Cordova. So I've been in the neighbourhood for quite some time, watching its decline, and recently, the slow process of its gentrification.

AA The 100-block of West Hastings, featured in your panoramic photograph *Every Building on 100 West Hastings* from 2001, is just around the corner, isn't it?

SD Yes it is, it's just one block south of Abbott and Cordova. I think that's part of what got Gregory [Henriquez] interested in inviting me to do something. The *100 West Hastings* photograph depicts the neighbourhood as it was left to go fallow until it became commercially exploitable again. You might also want to note that the 2001 photograph looks at the block from the point of view of the building where the mural now stands. And, in a way, *100 West Hastings* shows the effects of the event that's being depicted in *Abbott & Cordova*.

AA What do you mean?

SD Well, the key thing about the riot is that it changed the character of the Downtown Eastside for decades. In the 1970s, Vancouver mayor Tom Campbell initiated what he called "Operation Dustpan," a plan of police action to sweep away "filth"—i.e., hippies—from the streets. Hippie Central was in the west-side Vancouver neighbourhood of Kitsilano. The mayor thought that the things the hippies were doing there were immoral and often illegal but somewhat contained, which enabled the city to police them. When the hippies began to move downtown, squatting in old commercial and industrial buildings in Gastown and mingling with the locals, the police started to arrest or harass them with claims that they were selling drugs.

But after the 1971 riot, new zoning regulations made residential occupancy impossible. The Woodward's department store had always been the retail centre of the city for lower-middle and working-class people who couldn't afford to shop at more uptown establishments. But then shopping malls began to open in the suburbs, and Gastown became almost exclusively a tourist zone, buzzing during the day but desolate at night since there wasn't a mix of local residents with a personal investment in the

neighbourhood or in the surrounding area. Woodward's was bound to fail under these conditions, and closed its doors for good in 1993.

AA Did you conduct a lot of research prior to setting out to re-stage the event?

SD Yes, I hired a researcher, Faith Moosang, who dug up news clippings, photographs, and hand-written affidavits of the arrested, as well as civic policy memos and reports. She also did a series of interviews with a sample of those who were at the riot: police officers, shop owners, and countercultural types. What the interviews revealed was just how terrified everyone was. For instance, the police, and the mounted squad in particular, had never been involved in anything like that before, and there was a general sense of panic on both sides.

AA *Abbott & Cordova, 7 August 1971* is one of the four large digital C-prints that comprise your *Crowds & Riots* series. What led you to employ the loaded term of "riot," as opposed to, say, "uprising," when naming this series?

SD Well, three of the four events depicted in the series are of "police riots," in which the very actions of the police generate the kind of violence that they are presumably meant to contain. But on another level, the four photographs represent the organization of people into a group or a body by either internal or external forces. The Free Speech Demonstration of 1912 is related to the efforts of the Wobblies who came to Vancouver from the US in order to organize unemployed men. In response, the city outlawed public gatherings of more than a handful of people, as well as speech-making by all organizations other than the Salvation Army. The IWW agitators got around this by collaring people in alleys and making announcements by megaphone from boats in English Bay. They were able to get thousands of people to the Powell Street Grounds for a demonstration, which was ultimately broken up by cops wielding cudgels and bullwhips. Here, external agents tried to create a mass body.

The Battle of Ballantyne Pier took place in 1935 when about 1,000 unionized longshoremen, who had been dismissed and replaced because they had protested the way work was being allotted, set out to confront the scab labourers but were themselves intercepted by federal, provincial, civic, and special police forces who engaged them in a three-hour struggle. In this case, a group of people identified themselves as a single body.

The Hastings Park photograph represents people at the racetrack who, unbeknownst to them, have been made into a mass of consumers.

The Gastown photograph depicts people who have coalesced as a group through their

own shared values and camaraderie, but who have also been singled out as a group by the police. In the picture you can see middle-class people and working-class older men who watch the action as if it were street theatre. That's something I noticed in photographs and film footage from the time. People who couldn't be outwardly identified as hippies didn't feel threatened by the police action. They just watched as if it were some kind of entertainment.

AA What kind of reception has *Abbott & Cordova, 7 August 1971* received?

SD People seem to either love or hate it.

AA How have the local police responded to the photograph?

SD Funny you should ask. Two days before shooting, we got a call from the Chief of Police, or rather his executive assistant, summoning me to his office to explain what the hell I was doing. He added something to the effect of: "We've been trying to live this down for thirty-five years and now you want to make a mural out of it?" And the call probably came about because our horse wrangler, with our approval, contacted the mounted squad to ask if they still had any vintage tack. He also asked if any of them wanted to be in the picture. We naïvely thought that, forty years after the fact, it was obvious that the riot-making police force of 1971, subject to and modified by an inquiry (the so-called Dohm Commission) the same year, wasn't the same force in place today. The 1971 inquiry sought to prevent this kind of riot from ever happening again, and resulted in changes in police policy. The police, after all, are civil servants, and are accountable to the public. But one of the many problems in the Downtown Eastside right now, the Woodward's complex included, is that certain areas are designated private property and patrolled by private security companies which, unlike the police force of 1971, are not answerable to citizens.

AA You note that city regulations were changed after this event. Are all four events in the *Crowds & Riots* series pivotal in that sense?

SD Yes, to a certain degree. But the earlier instances were moments of failure. The police were able to disperse the body created by the IWW in 1912, and the longshoremen who clashed with the police in 1935 failed to reclaim the status that they thought was their due. And of course the Hastings Park photograph is an image of a group of people in a moment of repose waiting for a horse race to take place so they can find out if they've made the right wager—unaware of, or indifferent to, the fact that they've been produced as a group by the owners of the race track.

AA So these four historical cases are moments of crux, of transition?

SD Exactly, yes.

AA What do the events of August 7, 1971, signify today for Vancouverites?

SD Well … my photograph.

AA Are you suggesting that historical memory about at least this event has now become an image?

SD I think so, yes. And I'm not being entirely facetious. The photograph has produced an image of something that could easily be forgotten; it consolidates hearsay into a picture that will hopefully produce more hearsay and a conversation about history—as opposed to the way that, for instance, a sculpture of a general on horseback is supposed to do, but doesn't.

AA So the photograph effectively recharges the old centre of the city with its own history, and in that sense functions as public art.

SD Absolutely. But rather than fetishizing a historical moment, this photograph condenses it. I tried to condense as much as I possibly could into one image. Note that the title is very bland, with just the date and location. People have been clamouring to have some kind of plaque with a phrase or a paragraph that explains the events we've depicted. But I wanted to avoid that. I'd rather that the photograph produce a conversation between people. And, in fact, it has. I've seen the image prompt many people at the site to ask others what they are looking at. They want to know when and why the historical events depicted took place. People want to talk about the events. And that interests me very much.

A lot of conventional public art uses a plaque to explain why something that would normally be found in a museum has been placed out of doors, or what some man on a horse accomplished in this or that particular location. Such works become subordinate to their explanation. In contrast, I wasn't interested in the image conveying a single message. I was more interested in facilitating a conversation between people about a historical event, a series of historical events. In that sense, even the book in which this interview will be published is very much part of that conversation. And I'd rather something as multivalent as a book pry open the photograph, or elaborate the discussion about the photograph, than a single plaque that reads: "On this spot, on August 7, 1971, Police Beat Up Some Hippies."

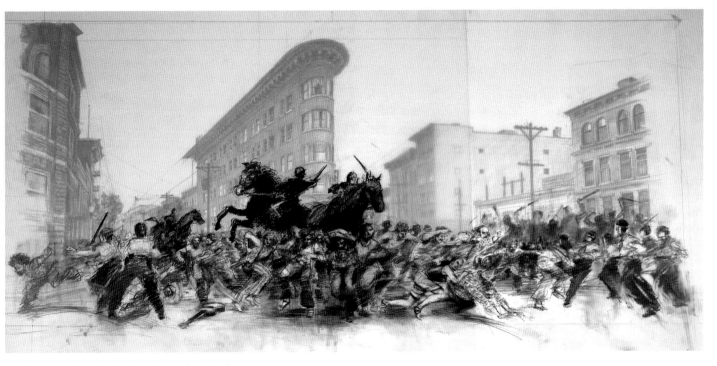

Neil Wedman, *Study for Gastown Riot*, 1998. Pencil on paper/
Pencil on mylar, 15.5 x 33 inches. Courtesy of the artist.
(Photo: Althea Thauberger)

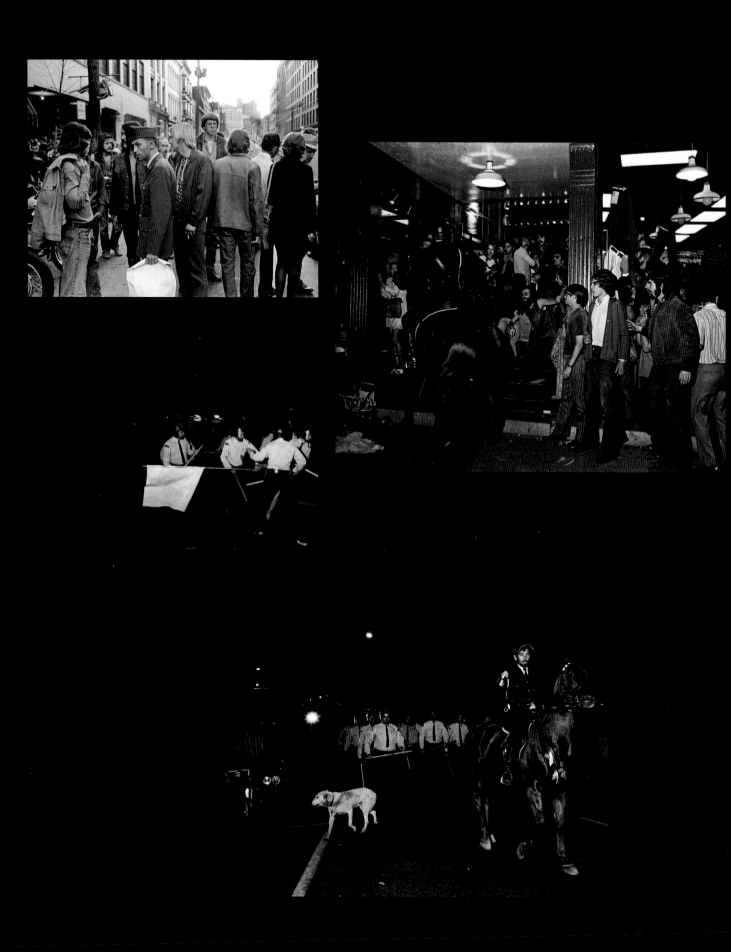

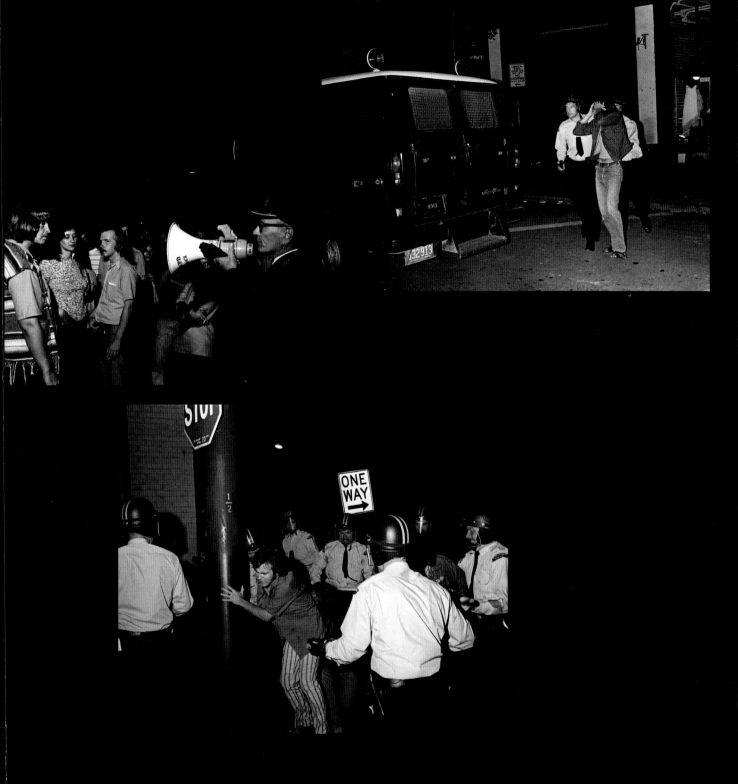

All images Gastown, August 7, 1971
(Photos by Glenn Baglo / *Vancouver Sun*)

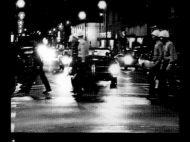

1

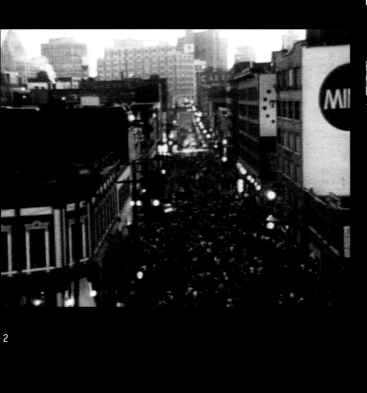

2

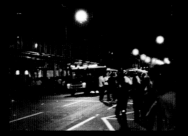

3

4

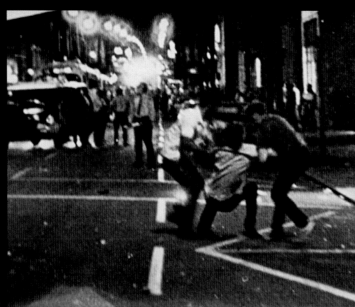

5

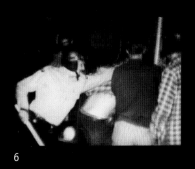

6

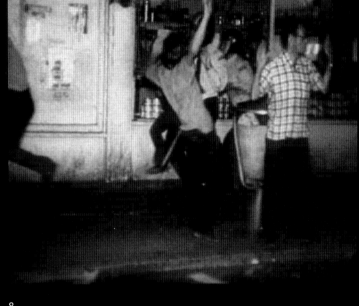

8

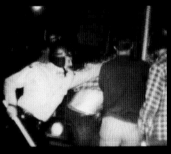

9

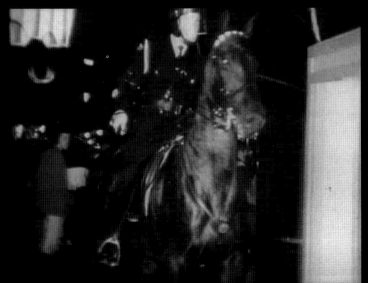

1, 4, 5: Gastown Riot. UBC Archives,
Georgia Straight collection, Vancouver, BC

2, 3, 6–10: Gastown Riot. Video stills,
"Summer Weekend" (aired August 15,
1971). CBC Vancouver Media Archives

LIGHTNING FROM THE PAST
Police, Pot, Public, and
Stan Douglas's *Abbott & Cordova*

Serge Guilbaut

... [A]ll follow a logic of suspended time to suggest not only that the present is constructed on the basis of the past, but also that the missed opportunities of the past, and possible transformations or reconfigurations of their potential, retain a force through recovered memory.

—William Wood in Daina Augaitis, et al., *Stan Douglas*

Today the poor are important only to the extent that their presence can bring down property values and discourage development, rather than, as thirty years ago, threaten rebellion.

—Jeff Sommers and Nick Blomley, "The Worst Block in Vancouver," in *Stan Douglas: Every Building on 100 West Hastings*

A Sharp Riot Story

In the atrium of the architecturally refurbished iconic Woodward's building on the edge of Vancouver's Downtown Eastside, an imposing digital photograph (50 x 30 ft / 13 x 8 metres) composed by Stan Douglas is on display. Contrary to the by now traditional manner whereby contemporary photography is exhibited in museums or featured in private collections, Douglas relocates the medium in a powerful and specific space: the public sphere. The photograph, placed above a large doorway at the threshold between the atrium and the outdoor courtyard, is called *Abbott & Cordova, 7 August 1971*, and re-enacts the city's infamous Gastown riot that took place not far from that very site, on Cordova Street, in August 1971. (Significantly, Douglas has chosen to make the Woodward's building part of the backdrop rather than Maple Tree Square, which had been the centre of the conflict.) In the forty years that followed, the Gastown riot had been largely forgotten and relegated to history, but Douglas's installation has revived interest in the event. Even if the events in Vancouver in 1971 were not as bloody or violent as those that took place in Europe and the US in the 1960s and '70s, the clash between hippies, tourists, and city police was a turning point in Vancouver civic politics—an urban trauma. What happened then triggered a series of events and political debates that are still very much alive today in the discussions around urban communities, marijuana laws, and gentrification. Compared to other infamous protests (Kent State, Paris, Mexico), the demonstration in Gastown was intended to be a rather calm and cool affair. It was, in fact, organized as a traditional "be-in" (as opposed to a traditional sit-in) to protest the use of undercover police officers and to promote the

28

legalization of marijuana, elevated to the status of a "smoke-in" by local newspapers; a youthful call for freedom—freedom to be different from the establishment, without much direct political discourse. Smoking marijuana in public seemed to be enough to symbolize this independence. The new *Georgia Straight*, a communal, "independent" free newspaper in Vancouver and the voice of the new generation, encouraged this San Francisco-hippie style of gathering, calling for the takeover of a low-key municipal space, specifically an underdeveloped space in East Vancouver. The protest was planned as a visible, joyful symbolic gesture in opposition to the police harassment of hippies and dope smokers, who were characterized by Vancouver City Hall as perverts and "trash." City Hall wanted to get rid of them in order to keep the city clean, while the hippies wanted to be recognized, seen, and understood—a perfect storm for what was to come.[1]

The protest on August 7, 1971 started out well. Decriminalization of marijuana was the cry of the day. A ten-foot-long papier-mâché joint was passed around in full view of passersby and tourists. According to a nine-page affidavit filed at City Hall, by around 8:50 p.m. a crowd of about 400 people had assembled, listening to a gospel group on one side of the street and another group playing African drums in front of the Hotel Europe. The crowd was singing. Vancouver's mayor, Tom Campbell, attempted to address the gathering from the balcony of the Hotel Europe, but to no avail, as he was drowned out by the chorus of voices. Campbell then left the scene,

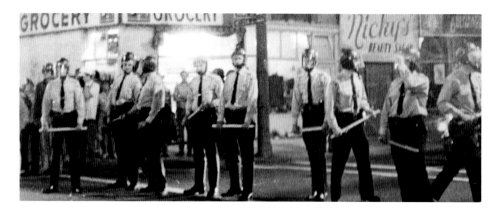

Gastown Riot. UBC Archives, *Georgia Straight* collection, Vancouver, BC

1 A short history of the Gastown riot:
 January 25, 1971: 200 poor people marched on Vancouver City Hall.
 June 23: Vancouver mayor Tom Campbell visited the Four Seasons' site at the entrance to Stanley Park and verbally sparred with young people squatting there.
 August 7: The "Battle of Maple Tree Square" (a.k.a. the Gastown riots), drew more than 11,000 people to Gastown to protest against the illegality of marijuana. Police on horseback were called in to break up the, demonstration arresting seventy-nine and charging thirty-eight protesters.
 August 14: The "Gastown Festival," meant to repair the area's image, was held one week after the riot. The event drew 15,000 peaceful participants.

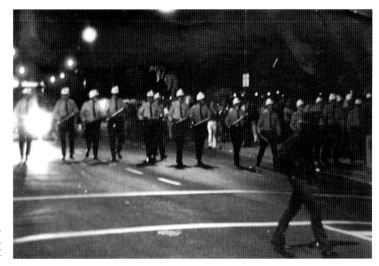

Gastown Riot. UBC Archives, *Georgia Straight* collection, Vancouver, BC

apparently upset. But what became a focus of attention, triggering laughter from the crowd of youths and tourists, was the moment when two young men climbed up the ornamental pillars of the Hotel Europe to the balcony and then exposed themselves to the gathering below. At the same time, two others climbed up to the hotel roof to install two black flags, well-known symbols of anarchy. The protest took on a party atmosphere; eventually, to shouts of "Down, down, down," the throngs settled down to listen to the music while many others started to leave.

Suddenly a large group of police officers[2] arrived on the scene led by four policemen on horses, as if to signal an upcoming apocalypse. Without much warning, according to witnesses, they charged into the crowd. People started to run in all directions while the cops pushed people into windows, dragged them by their hair, and beat them with three-foot-long nightsticks and batons. Several witness testimonies mention the fact that the police were not wearing badges so could not be easily recognized, and that some were actually embedded in the crowd, dressed as hippies, complete with flowered shirts and bell-bottom pants.[3] Angelika Zessel wrote: "I could not believe what was happening—[maybe] if I were in Chicago ... but in Vancouver?"[4] The outrage

2 The group consisted of eighty policemen on foot, four on horseback, and fifteen undercover officers dressed as "hippies," bearded men with flowery shirts and jeans.

3 Some photographs from that day show a group of smiling hippies/cops standing on guard before going into the street that day.

4 In another affidavit, an anonymous witness wrote: "This is outrageous. I belong to what some would call the establishment but I strongly protest this kind of action by the police (blood-hound I should say—a pig would never act like this)." On the other hand, the mayor received several letters of support from people who were not witnesses but who read reports in the press, such as Vancouverite B.E. Biggs, who wrote: "First, let me say that I'm 30 years old and pay taxes on my own house (clear title). This morning's news carried the story of a riot in Gastown with a bunch of idiots and the comments of two aldermen. These aldermen *thought* the A.S. should be called on to investigate the police. These two aldermen shouldn't be trying to *think*, neither of them has had enough practice. I support the police and sincerely hope you feel the same. I'm tired of paying taxes for youth on welfare, opportunities for youth hand-outs and half a dozen other half-baked ideas." The mayor's office also received a letter from B.R. Barnes, the vice-president of the Canadian Woman's Christian Temperance Union, supporting the police against anarchy. A retired owner of a drugstore referred to the communist threat of the 1930s and Vancouver's labour history: "It is most revealing, although conditions were not nearly so bad in Vancouver as they are now. At that time it was all due to the Depression, but the communists seized on that opportunity as they have always done. We now have the Drug problem, the young people roaming across Canada, draft dodgers and deserters from U.S.A., the Québec revolution, labour unrest etc. in addition to unemployment."

among witnesses was such that some, like Charles Traynor, the owner of Tin Ear, a record and stereo store in the area, were ready to take civil action against "as many of the officers as I can, due to the beatings which I witnessed personally." (Traynor himself was jailed until five in the morning when his lawyer came to free him.)

The police officers' ferocious charge into the crowd started after one of them, using a bull-horn, ordered the crowd to disperse, but he was ignored, although this was largely due to the fact that people could not hear him over the loud drum music. As police, participants, and bystanders did not know how to behave in such an unexpected and awkward situation, panic ensued. People were beaten and dragged along the street and sidewalk, many lacerated by broken glass. Though it paled in comparison to workers' demonstrations in the Vancouver area earlier in the century, the Gastown riot nevertheless turned out to be a divisive marker in the history of the city. Mayor Campbell, who was trying to gentrify the area for commercial purposes, found this new surge of freedom and political action in the streets particularly annoying. In fact, these activities were disturbing his plans for the further "embellishment" of Vancouver's east side, which he had been working on for some time, with Gastown slated as a priority over Chinatown. On July 5, 1971, the mayor sent a letter to Dr. Gordon Shrum, the chairman of the BC Hydro and Power authority, asking him to organize the "removal of unsightly overhead utilities, with the exception of trolley wires." New sidewalks and street lights were proposed, as well as ornamental bricks installed in the streets: in all, it was a CDN $1 million project (over $5 million in 2011). The first development phase for Maple Tree Square was scheduled for September 1971, but Campbell's plan was jeopardized by the growing number of youths who were migrating to the area to live. From the city's point of view, this is what was at stake on the night of August 7: to get rid of this fringe element of youth. What was not understood is that this so-called fringe was, in fact, made up of passionate, rational young people whose actions were rooted in the pursuit of a better world and a new way to practice direct democracy. To them, the mayor, defending the old ways of doing business, was simply not in tune with the times.

This event still resonates with the public because since then, the "embellished" area of Gastown and the Downtown Eastside proved to be problematic, with the city unable to properly cater to its very complex community. Many residents moved out after 1971 because of new zoning regulations. The decades-long debate over what to do with the Woodward's site (once home to an iconic Vancouver department store and subsequently at the centre of the Downtown Eastside's impoverished community) was predicated on the demand by the city that some aspect of the redevelopment had

to include reasonably priced housing for local residents and other useful facilities for those in the Downtown Eastside. The Woodward's department store, long the engine of the community, had slowly become redundant and finally closed its doors in 1993, accelerating the decay of the entire area. In this sense, it is interesting to see that the image that Douglas produces is, at first glance, a reflection of, and on, life today in the Downtown Eastside. Indeed, if one wanders around the area now, one might well find oneself immersed in a sea of the drugged-out and homeless, with people running in the streets or being interrogated by the police. One can't help but make the connection with Stan Douglas's reconstruction of August 7, 1971, even if it is meant to recall another era.

Art *in Situ*: Tradition and Problems

Several attempts have been made to revive this historically rich enclave by introducing low-cost housing, but to no avail. In 2002, pandemonium erupted in the area when homeless people and activists decided to squat the then-empty Woodward's building and the surrounding streets, creating a makeshift tent city: a highly visible and newsworthy event for the press and concerned citizens alike, until the police, after a period of ninety days, entered the premises and evicted the squatters; different problem, same solution.[5] It was in this dire environment that the architect Gregory Henriquez, after a very long period of public debate over what to do with the Woodward's site, reconceptualized the area, revitalizing it through diversity in a design based on past history and tradition. It is here that the installation of Douglas's photograph stands and functions as a sign of both the past and the present. The image is placed in an elevated position in the new public atrium facing a semi-public outdoor space and surrounded by a vibrant, diverse scene (Simon Fraser University classrooms, retail shops and restaurants, and mixed housing); the area is designed in such a way that it might "spread out" into the larger community in the hope of somehow transforming it. The importance of Douglas's public image, which appears to float in mid-air and is visible from both inside and outside the atrium, resides, in part, in the fact that it

5 On October 24, 1968 the University of British Columbia's faculty club was the site of student unrest when American Jerry Rubin and a number of UBC students invaded the club and took it over for twenty-two hours, after which they left voluntarily. At Simon Fraser University, students protesting against the school's admissions policy ended a three-day occupation of the administration building on November 25, when a squad of 100 unarmed RCMP officers arrested 114 people—almost one officer per protester. SFU's brand-new president, Dr. Kenneth Strand, who had called the RCMP in, used a bullhorn to warn the students to vacate the premises. The *Province* newspaper printed the protesters' names, ages (most were from eighteen to twenty-two), and addresses, and noted that Strand said the university had adopted a "get-tough" policy in the wake of the occupation.

represents the history of a specific site, a rich *lieu de mémoire,* a traditional point of social and political struggle. Transformation, change, and the conflagration of cultures are some of the important issues that Douglas's photograph addresses.

In the past, art has been an important part of the reorganization, indeed of the gentrification of public spaces. Too often, however, the tradition has been to drop art in the middle of a site, what artist Daniel Buren has described as *merde d'artiste*, a piece that has more to do with the developer's ego than the art itself, hidden beneath a veil of charity or culture, with a view to providing the general public with a kind of dull entertainment. Since the 1980s, different attempts have been made by contemporary artists to avoid having their work treated in this way. Miwon Kwon, in her book *One Place after Another: Site-Specific Art and Locational Identity*, convincingly analyzes this evolution: "Many critics, artists, and sponsors agreed that, at best, public art was a pleasant visual contrast to the rationalized regularity of its surroundings, providing a nice decorative effect. At worst, it was an empty trophy commemorating the powers and riches of the dominant class—a corporate bauble or architectural jewellery."[6] Vancouver, like other cities in North America and Europe, experimented with the incorporation of art into public spaces. In France, one percent of the total cost of a public building must be devoted to original art work by living artists. In America in the 1970s, corporations funded the purchase of art to adorn office buildings, shopping malls, banks, and the like, creating a new kind of "public" space run by business ideology (privately owned, publicly accessible). At times, the art was even the result of national contests to convey a sense of general consensus.[7]

6 Miwon Kwon, *One Place After Another: Site Specific Art and Locational Identity* (Cambridge, MA: MIT Press, 2004), 65. At the end of the twentieth century, one could find other attempts to answer this need from communities to use art for public consumption, but emanating directly from the public sphere. Francois Hers and the Fondation de France, for example, have developed an ambitious program in which ideas for public artwork come from the community itself (a village mayor, factory workers, a hospital) before being helped by the foundation to find artists as well as funding. Hers explains the protocol of action of the New Patrons program this way: "To every person who wishes, within civil society, the means to take on, either singly or in association with others, the role of commissioning a work of art to an artist; it also offers to give such people the means to legitimize an investment in its creation which will be requested from the community. In this way, it is up to the person in question to understand and to state a reason for what art is meant to be … In committing to an equal sharing of responsibilities, all players agree to manage through negotiation the tensions and conflicts inherent in public life within a democracy. The work of art thus ceases to be merely the expression of some- one's individuality and becomes also the expression of autonomous persons who have decided to form a community in order to invent new ways of relating to the world and to give to contemporary creative activity a shared meaning." (From a Fondation de France flyer entitled "The New Patrons, or Who States Art's Reason for Existing?")

7 Kwon, *One Place After Another*, 181, note 15. Sam Hunter describes the scene in the late 1970s: "In the seventies the triumph of the new public art was firmly secured. Almost any new corporate or municipal plaza worthy of its name de- ployed an obligatory large-scale sculpture, usually in a severely geometric, Minimalist style; or where more conservative tastes prevailed and funds were more generous, one might find instead a recumbent figure in bronze by Henry Moore or one of Jacques Lipchitz's mythological creatures. Today there is scarcely an American city of significant size boasting an urban-renewal program that lacks one or more, large, readily identifiable modern sculptures to relieve the familiar stark vistas of concrete, steel and glass." Sam Hunter, "The Public Agency as Patron," in *Art for the Public: The Collection of the Port Authority of New York and New Jersey* (New York and New Jersey: The Authority, 1985), 35, quoted in Kwon, *One Place After Another*, 64–65.

Site-specific works produced in the late 1980s, on the other hand, were important because they took into account the surroundings in which the piece was going to be presented. It was art *sur mesure*, like the making of a well-tailored suit, but it also came with many problems, as symbolized most dramatically by the famous controversy over Richard Serra's piece *Tilted Arc*, installed in New York in 1981. This large iron structure/sculpture was placed in the middle of the circular Federal Plaza, essentially dividing it in half; it was seen by a large part of the public as violating a "public amenity" in its cumbersome obstructiveness (in addition to being described as "ugly" and "non-artistic"). While the public hated being inconvenienced by the huge iron arc that blocked their path, for Serra the art was nevertheless deeply connected to the place. "The scale, the size, and the placement of sculptural elements result from an analysis of the particular environmental components of a given context,"[8] he wrote, encompassing social and political parameters. This particular controversy, which resulted in the removal and destruction of the sculpture in 1989, brutally clarified issues relating to public spaces: Public art should not put into question the utopian idea of communal spaces, and should not emphasize the critical deconstructive role of art. By the 1990s, art in public places in general was widely criticized by contemporary art critics as being too close and even often complicit with gentrification, despite the lack of any form of critical analysis of the situation.[9]

It is in this context that Stan Douglas's photograph positions itself. With the introduction of historical memory and debate in the work, the piece avoids being construed as mindless urban decoration. On the other hand, even if recalling a memorable event, Douglas's image does not function as a "monument" to that event, along with the commensurate associations of respect, pomp, and circumstance, but rather works as a philosophical and critical apparatus. It is in effect a disturbing open forum of ideas, where one can connect a specific past event with the ongoing, unstable present in order to produce a kind of recalibration or recharging of the soul, so to speak. What Stan Douglas uses is a particular and specific "event"—the Gastown riot—to tell a story: that of the historical memory associated with a specific site. That is why in order to activate that memory, the artist had to thoroughly research the

8 Richard Serra, "Tilted Arc Destroyed," in *Writings/Interviews,* Richard Serra (Chicago: University of Chicago Press, 1994), 193–213.
9 But other experiments were available; some artists, looking back to the Russian Revolution, preferred to bring into depressed spheres objects with art gloss such as benches or tables, to give the community some comfort and to give art the power to be useful. Others preferred to intervene in the everyday by appropriating corporate sites like billboards or television ad spaces in order to try to subvert their ominous total control. A good example is Stan Douglas's 1994 work, *Evening*. This is also the period when artists were interested in re-enacting events. The best known and most elaborate is Jeremy Deller's piece *The Battle of Orgreave* (2001), which re-enacted the charge of a police battalion against unionized miners on June 18, 1984 during a year-long strike against Margaret Thatcher's union-breaking policies. The film was a mixture of new reconstitution and past documentary.

event in the City of Vancouver's archives, reading dozens of letters and affidavits from those who were there on August 7, 1971 as well as members of the general public. He discovered that many citizens were outraged by the events of that night, and some were surprised, but there were some who were supportive of the police's actions. Stan Douglas's photograph asks us to reflect on all of the above.

Re-enacting the Past

An old guy with a bald head and grey beard is standing in the middle of the Woodward's redevelopment. He's smoking a cigarette and looking up at the huge photo mural on the glass wall that divides the site's outdoor courtyard from its indoor atrium. 'That's not a scene that people in Vancouver want to remember,' he declares.

—Robin Laurence, "Vancouver artist Stan Douglas revisits the 1971 Gastown riot," *Georgia Straight*, December 30, 2009[10]

Why not? Some Vancouverites obviously do, and that is part of the power of this highly visible artwork: the reintroduction of memory and history writ large into the Downtown Eastside community that for so long has been robbed of its past and made to hide under a blanket of shame and embarrassment. But this process of giving a renewed voice to a community is a tough one, as Hal Foster explains: "To a great extent, the left over-identifies with the other as victim, which locks it into a hierarchy of suffering whereby the wretched can do little wrong. To a much greater extent, the right disidentifies from the other, which it blames as victim, and exploits this disidentification to build political solidarity through fantasmatic fear and loathing."[11]

10 See Robin Laurence, "Vancouver Artist Stan Douglas Revisits the 1971 Gastown Riot," *Georgia Straight* (December 30, 2009), at http://www.straight.com/article-277538/vancouver/battle-gastown.

11 "I was very surprised," Douglas said. "I was actually waiting for someone to—I was kind of disappointed that nobody was upset about this project, about this idea. I thought I was being very subversive, and no one's complaining," he added. "What the hell's going on?"? (Leigh Kamping-Carder, "At the Gastown Riot," *The Walrus* [July/August 2009], at http://www.walrusmagazine.com/articles/2009.07-profile-at-the-gastown-riot-stan-douglas-walrus-vancouver-art/1/) Current Vancouver mayor Gregor Robertson, who is Chair of the Vancouver Police Board, managed to show that time has passed and things have evolved in a civilized direction: "It was a moment in time and I know some people are upset about it but it tells a story about a piece of Vancouver history," he said. "But I think we've come a long way since then. You wouldn't see that in this day and age. So it's an interesting contrast to what's happening in these times where there's a ton of community support work done by the police." (http://pricetags.wordpress.com/2010/01/20/woodwards-3-stan-douglass-abbott-and-cordova/) Others have an ironic view of Douglas's work, while some have been dismissive: Take5, a Downtown Eastside graffiti artist and resident of twenty years, commented online in response to Leigh Kamping-Carder's *Walrus* magazine article about the piece: "While I find this image to be very well composed, and the process in which it was created quite fantastic, I found the content of the image to be very defeatist and an ever lurking reminder how the residents of the DTES are oppressed on a daily basis ... I also found it regrettable when I heard the budget/

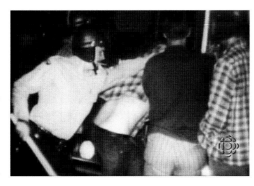
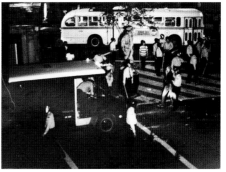

Left: Gastown Riot. Video stills, "Summer Weekend" (aired August 15, 1971). CBC Vancouver Media Archives

Right: Gastown Riot. UBC Archives, *Georgia Straight* collection, Vancouver, BC

Faced with this impasse, critical distance might not be such a bad idea after all."[12] It is this type of critical distance that Stan Douglas is known for and which he confronts here again through a staged photographic reconstruction of past history. We know, of course, that history has often, if not always, been written from the point of view of the "winners"; Douglas thinks and practices differently. He helps to reassess the way in which we have been historically constructing our world and, in doing so, puts some grains of sand in the usually well-oiled historical machine. Looking askance at traditional history, the one discussed and articulated by writers like Roger Chartier or Michel de Certeau, Stan Douglas has developed a complex relationship to history: a mixture of faith and fascination with a strong suspicion about archives, while still preserving the idea that they can help to illuminate the past.[13]

We are living in wonderful times. Through online sources we can now find historical as well as personal information about anything or anyone. So it was interesting to proceed, with caution, as I did online and find images of the 1971 Gastown riot. There is an anarchist site that presents, in graphic detail, the violence of the encounter between Vancouver police and the general public, which had been filmed vividly in black and white by a television crew. Superimposed on this footage is an interview shot in colour with Mayor Tom Campbell contradicting, without much shame, what one can witness on the screen behind him. The juxtaposition is effective, as the viewer is privy to the reality of the violence perpetrated by the police and the mayor's attempt to diffuse the situation, despite the fact that a large majority of the press coverage suggested that it was the police officers and not the hippies who were rioting.[14]

This intriguing moment in Vancouver history can now be stored in our smartphones or on our iPads and shown in bars, at parties, and in classes. But is it really discussed? Not really, not by many, but what is certain now is that this event, with all the memories attached to it, is not only visible but also hugely present in a public space not far

commi$$ion for this photo-shoot was between $1 million and $1.5 million. While I am completely supportive of arts & culture in the DTES, this sum of money is superfluous to pay to ONE artist when there is so much poverty, so much homelessness, and so much suffering because people cannot afford to live ..." (Kamping-Carder, "At the Gastown Riot," *The Walrus* [July/August 2009]) [Editor's note: actual cost of shoot was $550,000.]

12 Hal Foster, "The Artist as Ethnographer," in *The Return of the Real* (Cambridge, MA: MIT Press, 1996), 203.

13 Roger Chartier, *Au bord de la Falaise, L'histoire entre certitudes et inquiétude* (Paris: Albin Michel, 1998) and Michel De Certeau, *The Writing of History,* transl. from the French by Tom Conley (New York: Columbia University Press, 1988).

14 See Vancouver Yippie! at http://vcmtalk.com/vancouver_yippie for photos and the Canadian Broadcasting Corporation archives at http://archives.cbc.ca/society/crime_justice/clips/3589/ for archival footage.

from the spot where the events of 1971 took place. The history of Vancouver's violence is now available everywhere, from our back pockets to public atria. It has become unavoidable. Stan Douglas, using the concept of public and political murals produced in the 1930s, manages to alert us, forcing us to reflect not only on our civic past, but also on our present responsibilities on how best to envision the future.

For maximum impact, Douglas subversively manipulates and hijacks the persuasive power of advertising. He uses something like a light box to illuminate our troubled past through the context of our contemporary perspective. Located inside a semi-private courtyard, facing the street, Douglas's work is a bridge between public and private spaces. Viewed from inside the courtyard, one can see the complex elements of its large photographic structure that connect the piece with the modernist tradition while, when viewed from the outside, one can see the dazzling postmodern effect of near-cinemascopic quality.

Stan Douglas proposes a re-enactment of important events that still reside in the memory of many Vancouverites while appealing to a new generation of citizens interested in the darker elements of the city's history. The Hollywood qualities of the image bring with it a sense of saga, potentially a momentous historical event—even though curiously downplayed here, the historical representation of another time is fraught with contemporary ramifications, given that the city is still grappling with problems of drugs, poverty, anonymity, identity, gentrification, and violence. The past has suddenly become contemporary: the cinematic effect transforms the past into the present. It literally glows in the sky for everybody to see, reflect on, or express wonder at. As its creator, Stan Douglas sets the scene like a Hollywood director. Streets have been constructed and decorated, and actors have been chosen, it is true, but as an artist Douglas does not play the role of a documentary reporter or that of a traditional screenwriter; he is rather a *nouvelle vague* editor/narrator. His approach is a kind of archeological process in which he creates carefully chosen, telling images. His controlled theatrical set allows him to produce a sort of collage or, perhaps more accurately, a form of cinematic "montage" using modern cinematographic techniques to instigate a collision of images that serve to undermine any sense of linear narration. Here, blocks of images, of scenes, each shot independently, are then forced to confront one another, are juxtaposed in order to open the field for interrogation and self-questioning and avoid a static, repressive discourse. This technique produces an unsettling narration, open to questioning, as the work is not a tracing but a map, not an imprint but an allegory. The photograph does not replace the real but tries, through a large amount of archival research, to represent the event with some

fidelity to various witness accounts. *Abbott & Cordova* is, then, a collage/montage of historical moments that the artist wishes to present again in order to re-activate the social past of the community. Spaces left empty between groups of images free them from becoming a controlling machine. This compilation of small, isolated events allows the viewer to penetrate inside the picture as if by chance, allowing and even somewhat pressuring him or her to investigate it. Once inside this virtual space, the viewer has to imagine how he or she would act in a similar situation. Here there is no discourse of truth, no images fixated as totality, only juxtapositions of possibilities. This represented past has been thoroughly researched by the artist, who is aware of the theoretical discourse about archives. The task is to sort through a wide range of still-active positions, ranging from the naïve love for truth to the cynical knowledge of archival manipulation, while coming to grips with the artist's role of imposing a vision. In *Abbott & Cordova*, Stan Douglas imposes questions. He redistributes old cards, like traditional forms of narration, in order to imbue our contemporary scene with the possibility of rereading the past, to learn about yesterday in order to better read today and maybe invent tomorrow. But he is also aware of this new popular tendency to be so open in the reading of history that one tends to accept almost any interpretation amid a sea of relativism. If everything has the same weight, it becomes difficult to take social, political, or ethical positions. This is not what Stan Douglas is about. One can be complex and open to discussion without being ineffective or irresponsible. In a sense, Douglas tries the impossible, or rather, tries to represent the non-representable, to deal with what subtends the image. It is a difficult task indeed, because to put too much life into it might lead to chaos, while introducing too much representation would certainly lead to death.[15] The crisp, high-definition image appears to hover there in mid-air as a public statement, as a call to question, for a democratic exchange about the past of a *lieu de memoire:* a particular site of memory around which contemporary issues about the identity of the area can be debated. This is why the work is not a photograph/tableau relegated to the confines of a gallery or museum. Nor is it a video, one of those pieces common in museums these days but rarely viewed in their entirety, so bored are we with television's manipulations and lies.

In a sense, this is a new form of public art, a scream in the night, a wake-up call, executed with historical care and openness. The recipe is clear: it is not documentary but rather a well-documented construction of the past with several crucial moments of *engagement.*[16]

15 Perhaps that is why, on the one hand, Douglas was surprised by the general lack of resistance to his work and may also explain the diverse type of reactions, e.g., that it was too pretty or not subversive enough or even too self-centred.

Visual Labyrinth

Abbott & Cordova is a carefully organized representation of a dramatic moment in Vancouver's past, a past whose class tensions have yet to be resolved despite a general economic boom generated in part by a highly visible international fair (Expo 86) and the successful (yet controversial) 2010 Winter Olympics. It is for this reason Douglas's work is an important public statement on the same level as traditional popular-front murals and revolutionary Mexican frescoes, but with a postmodern twist, as it denies the viewer a singular reading, a characteristic of propagandistic murals. Douglas's photograph is a democratic interrogation rather than a traditional political manipulation. But how does he do it? How does he bring back the past, the memory of the place, without being didactic?

Douglas chose to recreate the most violent moment of the August 7, 1971 event when four police officers on horseback charged into the crowd. This particular moment has been cited as a turning point in the city's history, igniting years of heated debates regarding the Downtown Eastside. Douglas's re-enactment of such a momentous event in Vancouver's history is a powerful tool for the reactivation of democratic discourse. In carrying on some of the legacy of the May '68 events in Paris, the French philosopher Alain Badiou has managed to theorize the important notion of *l'événement*:

> An event for me is something which brings to the fore a possibility which was invisible or even unthinkable. An event is not by itself the creation of a reality; it is the creation of a possibility, it opens a possibility. It indicates to us that a possibility exists but was ignored. The event is in fact only a proposition ... It all depends on how this proposed possibility will be apprehended, worked out, incorporated, deployed in the world ... The event creates a possibility, but some work is needed, a collective one in the case of politics, individual in the case of artistic production, in order for this possibility to become real, that is that it inscribes itself step by step in the world ... The event will transform what has been declared impossible into possibility. The possible will be snatched from impossibility.[17]

Stan Douglas's work is a vivid response to the slogan written on Parisian walls in 1968: *Demandez l'impossible* (Ask for the impossible). Douglas, working through the

16 That is why Douglas includes an essay by Gilles Deleuze on "Humour, Irony and the Law" in Scott Watson, Diana Thater and Carol J. Clover, *Stan Douglas* (London, UK: Phaidon, 1998), 80-86.

17 Alain Badiou and Fabien Tarby, *La Philosophie et l'événement* (Paris: Germina, 2010), 19.

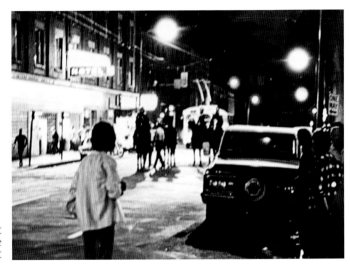

Gastown Riot. UBC Archives, *Georgia Straight* collection, Vancouver, BC

imagery, memory, and light of August 7, 1971, wants us, the public, to stay awake. This return to the past, to a moment of short but intense struggle, is crucial, as it contributes to the ongoing dialogue about the future of Vancouver's Downtown Eastside, still hampered by decay, drug use, and homelessness.

The idea of addressing present-day problems by reflecting on a specific moment in the past is a kind of "back to the future" exercise, again perceived by Badiou: "I think that the political subject is always in between two elements. He/she is never simply confronted with the opposition of the event and the situation. The subject is in a situation strained by events which are close or far away. The political subject is in-between the earlier event and the on-coming one."[18]

The site depicted by Douglas, Gastown and the Downtown Eastside, has long been home to working-class struggles, such as the relief camp strikers in 1935, and the unemployed workers who occupied the post office in 1938 (forcibly removed by policemen on horseback). It is this history that Stan Douglas puts into action in order to not only keep alive a very specific identity, but also to participate in an ongoing debate about the place, particularly with regard to the issue of homelessness. In this contemporary moment of reassessing the Downtown Eastside, the work *in situ* functions as both a reminder of another time and of an enduring struggle for the reorganization of a poor, working-class community virtually abandoned by the powers-that-be for decades. The latest conversations regarding the reorganization, rehabilitation, and gentrification of buildings around the old but cherished Woodward's institution revives the possibility of returning self-respect and self-esteem to a community with a rich history of defiance and struggle.[19] But in order to do so—to get back into history

18 Badiou, ibid., 23. In an interview with Linn Cooke, Douglas explained: "In terms of presentation and the subject matter, I have been preoccupied with failed utopias and absolute technologies. To a large degree, my concern is not to redeem these past events but to reconsider them; to understand why these utopian moments did not fulfill themselves, what larger forces kept a local moment a minor moment; and what was valuable there—what might still be useful today." In Watson, Thater, and Clover, *Stan Douglas*, 116.

19 For an important cultural and political analysis of the area, see Jeff Sommers and Nick Blomley, "The Worst Block in Vancouver," in *Stan Douglas: Every Building on 100 West Hastings,* ed. Reid Shier (Vancouver: Arsenal Pulp Press and Contemporary Art Gallery, 2002), 18–61.

so as to be able to understand the present and prepare for the future—one has to re-enter that world.

Douglas's photograph avoids direct confrontation or easy reading thanks to a centrifugal effect. In the image, several groupings of action are located around an empty centre, around a literal, empty crossroad delimited by white lines defined with a certain dose of irony: the protective pedestrian crosswalk. The entire area is structured around the empty space, proposing to viewers a complex grid (the vertical lampposts, the white parallel stripes of car lanes and crosswalks) in which several different scenes of action are positioned without producing chaos. Two buildings face each other across the street while three cars define the other limits where the fluid action is located (one red, one black in the foreground, and the paddy wagon). The street in the upper-right portion of the image is literally blocked by police officers and immobilized automobiles. Two vertical lampposts delimit our field of vision, while within it, three individuals cross the visual space, sprinting across the street toward the other side. What is particularly striking is that the organizational and framing grid is nevertheless still full of potential conflicts as people in the image are in motion, rushing in different directions. The youths running away from us toward the Woodward's store will clash with the two police officers in the midst of arresting someone, while the policeman on horseback is about to confront the group of people lined up against the car.

Once this first overall effect is visually integrated, the constructed photography—taken from above, a perspective similar to that used in Baroque church frescoes—brings the viewer inside the narration for a detailed reading, thanks to a visual trick: our gaze is eventually directed to an apparently discarded newspaper, present at the bottom of the photograph. It turns out to be a tattered-looking issue of the *Georgia Straight*, the alternative newspaper that encouraged the demonstration that turned into the violent confrontation displayed here. The presence of this newspaper, along with numerous scattered pieces of glass and flowers on the ground, pronounces the essence of this representation: the *Georgia Straight* being the fuse that started the event, and the broken glass and flowers being the result of the police assault. These symbolic and foreboding signs (police brutality, hippie love, flower power) are coupled with the image of two young boys sitting on the curb at the bottom right of the image, playing the role of a transition tool that leads us into the larger story developing around the frame. They are the entrance point for our gaze; nonchalant, a bit detached, but curious: one boy appears to be intensely trying to understand the event unfolding in front of him; the other, looking slightly backwards, shows some apprehension about the turmoil, announcing as well an unsettling future (i.e., today). They are us, looking

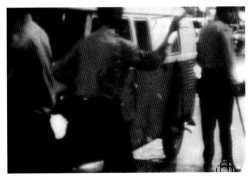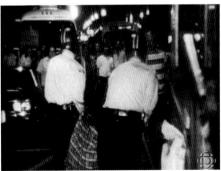

at the piece, amused and troubled but wanting to know more.

Alerted and attracted by the interrogative stare of the boy looking back at us (mimicking the backward gaze of the youth running across the street, illuminated by the street light), we are also projected toward a compressed scene referred to earlier, on the left of the composition, in the foreground. A row of youths, recognizable only by their long hair (a major issue in this event), is squeezed between a policeman on horseback and a car parked parallel to the picture plane and projecting out toward what seems to be the only way out: the empty centre of the composition. The bottom left section of the picture is constructed in such a way as to announce a clash of momentous proportions. It is a suspended moment as the horse, pushing forward across the space, will inevitably collide with the youths running against the current. It makes our minds accelerate with expectation and fear.

Several people out of this compressed line are running toward the centre, in the direction of the Woodward's store, where two cops are hauling away a resisting youth. Another young man, turning his head back toward us in fear of the violent commotion, is running away from the mounted policeman into a pool of light, but too close for comfort to another police officer, who is wielding a baton.

Then we are again attracted to the left by the intense red colour of a car, beside which two mounted policemen are pushing a small crowd against the door of a store. According to many written affidavits preserved in the City of Vancouver Archives, witnesses reported numerous instances of mounted policemen assaulting protesters, pushing them inside corridors and against walls and store entrances. Here one also finds a seminal image: a black man is segregated from the others by two policemen on horseback, framing him tightly before he will presumably be transferred to the already crowded paddy wagon located across the street, on the right side of the picture, where a long-haired man tries to resist being shoved inside. We then realize that two policemen on the other side of the street (one of whom was actually an undercover agent disguised as a hippie who had infiltrated the protesters), wielding batons, are bringing a bearded

42

man across to the same ominous paddy wagon. This detail is pregnant with symbolism since the man with long hair, beard, and blue overalls could represent either a 1930s working-class man, a 1970s hippie, or a homeless man today. The ongoing turmoil is obviously scaring a "cool dressed" couple standing near the corner of the sporting goods store; they seem surprised and even shocked by the unfolding violence. This aspect of the image suggests danger, as it takes place in front of a store, Sissons Sporting Goods, its sign offering "fishing tackle" and, more ominously, "guns & ammunition."

Our gaze then moves clockwise across the street, where we encounter a group of people in the distance, seemingly not part of the original demonstration, who seem to be casual observers, seemingly unaware or unconcerned by the apparent chaos. They are calmly looking at the two policemen as they drag a young man across the intersection toward the paddy wagon, symbol of authority and incarceration. They are smoking, talking among themselves, unthreatened by the violence in front of them, although the woman seems to be clutching her coat in what seems to be a protective gesture. The street on the right side of the image, in opposition to the chaos on the other side, is blocked by a large group of police officers standing in front of many cars in the middle of the street. Unable to proceed, their drivers are forced to watch the scene as if they were watching a movie at a drive-in. The spectacle is fascinating.

Finally, the viewer focuses on one last section: the paddy wagon in the bottom right of the picture, almost in our faces, the only section with directly visible violence. Here, several blue-shirted cops are shoving the long-haired protesters into the vehicle, again with the help of an undercover officer. What is interesting to note is that in all sections of the work depicting confrontation, the police are not shown as attacking the crowd directly, as was reported in countless witness letters. Instead, in spite of the pushing and shoving, the police appear to use their batons the way they were instructed to, in a defensive manner. The construction of the image has, then, been carefully orchestrated to be open-ended so as to make clear that several analyses and versions of the event exist; as such, it is far from being a piece of propaganda, a myth, or a populist manipulation. The image is not a utopian science fiction but rather a form of "back to the future," a kind of subversive action/discourse. It is nevertheless a crucial tool for understanding and sorting out, in public, the fate not only of a small community but also that of the generally threatened concept of democracy. A reflection on a riot is different from inciting one. Questioning and debating are different attitudes than rage, even if the rage was at the time understandable and necessary. This is why the mixed response to Douglas's art work *in situ* is interesting: on the one hand, it is ironically lauded—"… it is by far the 'prettiest' rendition of a riot I have ever seen. To

be honest, at first glance I thought it was an ad for the GAP"[20]—and on the other, outright dismissed for its suggested call to arms—"I hope Mr. Douglas contemplates the impact of his work in the community next time he is commissioned to do a public art project. I also hope he considers using a more exciting framework than what he called 'subversive' while composing his next work. I get more subversive with a can of spray-paint."[21]

Here, class divisions are clear. Messages about freedom and repression are open for scrutiny and the construction of the entire image is itself open; in a way, it is about the construction of the visual discourse itself. The blankness at the centre, this empty crossroads just beneath the checkerboard motif on the wall of the building, leads the viewer to ask him or herself about responsibility. On one side of the street we have guns in the window; on the other, the checkerboard pattern that suggests a game of chess, where a complicated game of politics will be played, complete with moving pieces, with particular dispositions and powers, including, here, the horses of law enforcement. In fact, the horse is a central component of the image, a sign of force as well as of animal violence and uncontrollability. Here, the fury of the police officers on horseback—a vision that shocked many citizens at the time—reaches back to a long tradition of military representation of victory first used on antique sarcophagi and triumphal monuments, then in powerful representations of saints like the famous Matamoros, Santiago de Compostela, trampling the invading Muslims on horseback in a sign of liberation. Douglas's depiction contradicts the traditional benevolent, benign image of the Royal Canadian Mounted Police, whose reputation has been tarnished in recent years as a result of numerous scandals and who, as a result, have been the subject of a symbolic beating by the general public.

The police officers' display of force and violence generated an interesting response from the general public in 1971. A festival of sorts was organized the following weekend not far from Gastown itself, with the aim of bringing together the families of policemen with witnesses and participants in the riot, in order to restore a sense of civility in Vancouver. The reunion was successful, attracting a bigger audience than the original demonstration;

Matamoros of Santiago de Compostela. Painted wood sculpture. Santiago de Compostela Cathedral, Galicia, Spain

20 Robin Laurence, *Georgia Straight*, http://www.straight.com/article-277538/vancouver/battle-gastown.
21 Take5 online comment on Leigh Kamping-Carder, "At the Gastown Riot," in *The Walrus* (July/August 2009).

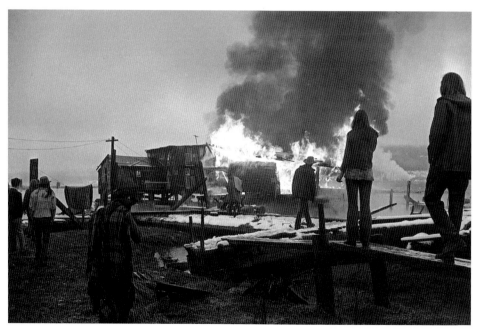

North Vancouver mudflats east of the Second Narrows Bridge, Sept. 12, 1971. (Photo: Dan Scott, *Vancouver Sun*)

as many as 15,000 people took part in the event, drinking beer, listening to music etc.,[22] projecting in public a pacified image of the area, corresponding to the wish of developers and corporate powers. But everything was still not perfect in this land of new "development." For example, in July 1971, Vancouver bohemians—poets and painters like Tom Burrows—who were residing in temporary structures in an area of Vancouver known as the Maplewood mudflats, were considered exotic and artistic, but by December 17, 1971, the area was cleaned up, the residents evicted, and their makeshift homes set on fire. This was a radical sweeping away of the old, to be replaced by new architectural developments. Scott Watson describes well what was at stake: "In 1971, most of a squatter community on the Maplewood 'intertidal' Mud Flats, near where Malcolm Lowry had written *Under the Volcano*, was burned to the ground by civic authorities, ostensibly to clear the way for private development. This was authentic un-commodifiable human habitation, the polar opposite of the condo. Squatting was also deployed to prevent the building of a hotel at the entrance to Stanley Park. (The site is today an extension of Stanley Park.) And squatting became a utopian model for self-determined 'villages,' self-sustaining communities in a city whose neighborhoods were being razed for condo high-rises." [23]

 The photographic image projected by Stan Douglas, frozen in time, interpellates

22 On August 10, 1971 Mayor Tom Campbell wrote to the Board of Police Commissioners, having decided that, due to public concern, he would have an inquiry done on the riots: "[H]owever, in view of the widespread public concern the Board has determined to forward the Chief Constable's final report to the board when completed to the Attorney-General, and to request that he determine whether or not he considers an inquiry independent of the Board should be held, and if so to arrange for such enquiry." The enquiry did happen, and Mr. Justice Thomas Dohm (who provided a balanced report according to the press) ruled that some six officers had indeed used excessive force. Despite the fact that City Prosecutor Steward McMorran said he "had sufficient evidence to warrant charges," the commission did not lay any charges against five of the officers. Only one officer was demoted by Mayor Campbell—not because of misbehaviour during the riot but because he failed to report that a young man had suffered a broken leg.

23 Dieter Roelstraete and Scott Watson, eds., *Intertidal: Vancouver Art & Artists* (Antwerp and Vancouver: Museum of Contemporary Art Antwerp and Morris and Helen Belkin Art Gallery, 2005), 30–49.

the passerby, posing the question: "Hey, do you remember us?" And, in fact, we do. As we integrate the composition so perfectly well in our heads, we can imagine its subjects as if in comic books, with big thought bubbles over their heads containing fleeting images of a specific past: violence, horses, debris, bongo music, paddy wagons. *Abbott & Cordova* is part of a new understanding of contemporary art, an art of looking again, aiming to participate in an active critical production located between what Georges Didi-Huberman calls the *lucioles* (those "fireflies" metaphorically representing the reappearance of tiny spheres of critical activity) and the crushing and devastating force of contemporary media manipulation that functions like military searchlights. *Abbott & Cordova* articulates through memory, through history, through its carefully constructed discourse; it is a powerful tool for the rethinking of not only contemporary photography, but also the new role of the intellectual following post-modernity. In our often bleak and sombre world, chock-full of crises, the work of Stan Douglas literally glows in the urban street. It is a subtle and small glow, despite the grandiose scale of the work, like those critical spaces Didi-Huberman[24] describes, but crucial in the restoration of a critical democracy. Those spaces are still small, but they start to add up when one looks at contemporary artistic production, creating a kind of "altermodernity" as Bourriaud calls it, ready to replace alienation and cynicism with a multitude of local insurrections against official representation of histories. Stan Douglas's image participates in this movement of ideas against static policies, private introspection, and cute art historical quotes.

Abbott & Cordova is able to articulate, in its constructed narration, vivid, crucial issues of freedom, democracy, confrontation, and political manipulation, still at the core of our everyday political and civil life. What is fascinating about this work is its sophisticated reworking of the important tradition of public murals produced by Mexican and other North American artists from the 1930s to the 1950s into a highly technological tool, capable now of articulating a complex visual discussion with a newly vibrant and aware public, without having to resort to propaganda.

Finally, with this work and others like it, the 1968 motto *L'intelligence au pouvoir* (Power to intelligence) demanded by the generation portrayed in *Abbott & Cordova*, might finally become a reality. Let's hope—without holding our breath.

24 Georges Didi-Huberman, *Survivance des lucioles* (Paris: Les Éditions de Minuit, 2009).

CROWDS & RIOTS, 2008

Stan Douglas

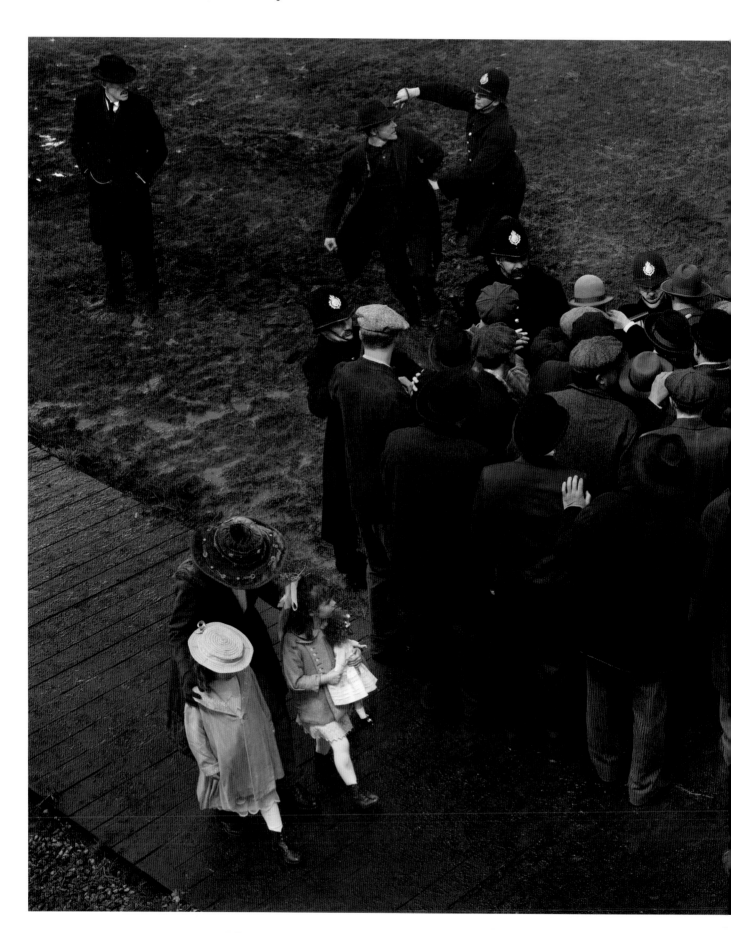

Digital C-print mounted on aluminum, 104 x 59.5 inches (264.1 x 151.1 cm)

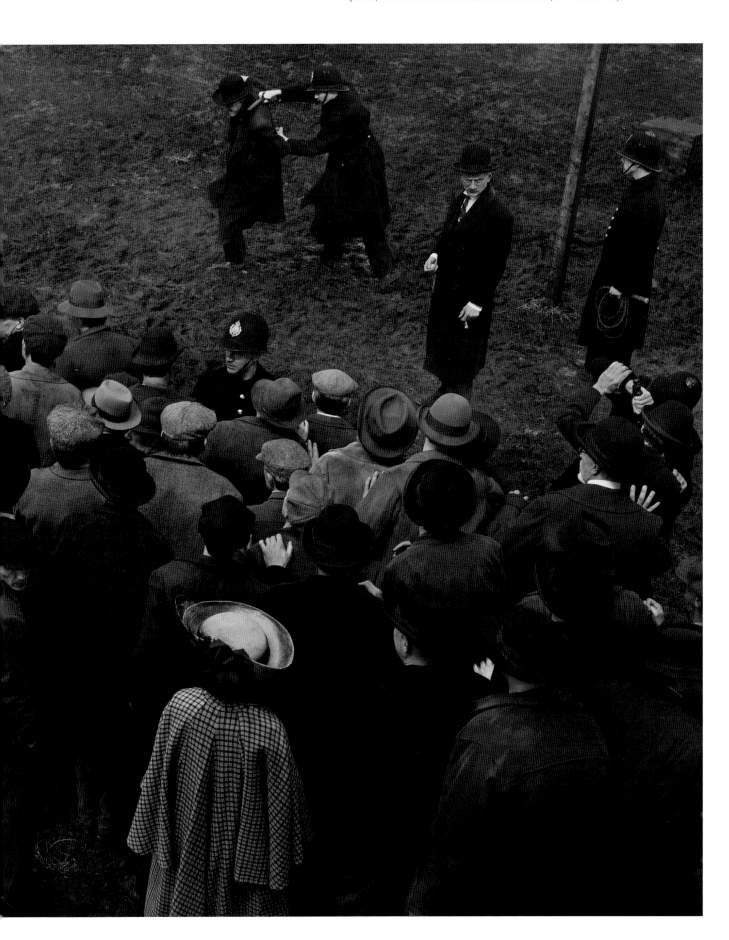

Digital C-print mounted on aluminum, 116.5 x 45.5 inches (295.9 x 115.5 cm)

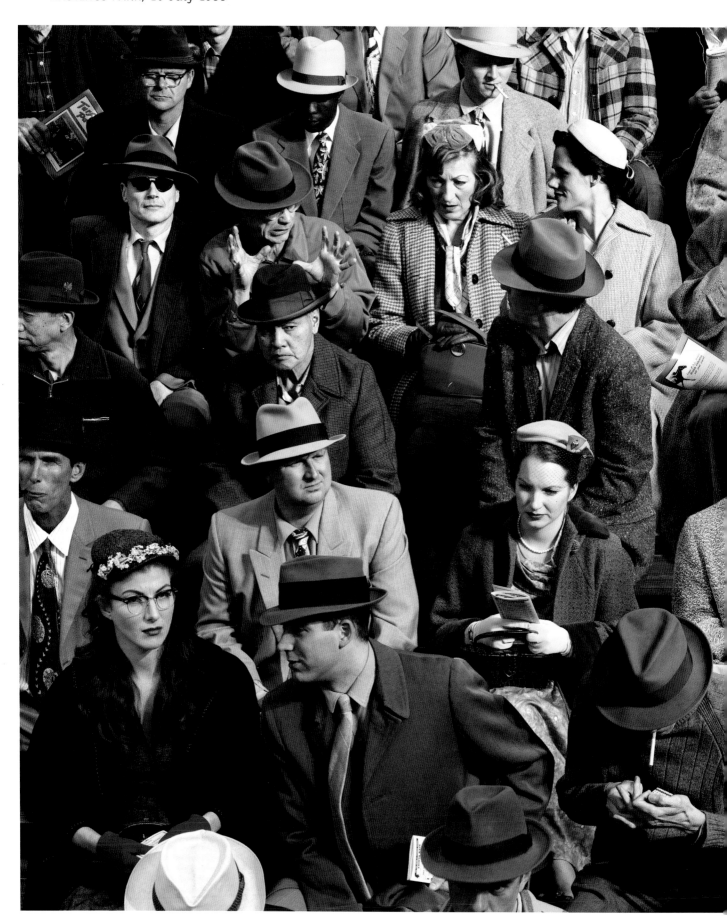

Digital C-print mounted on aluminum, 88.5 x 59.5 inches (225.4 x 151.1 cm)

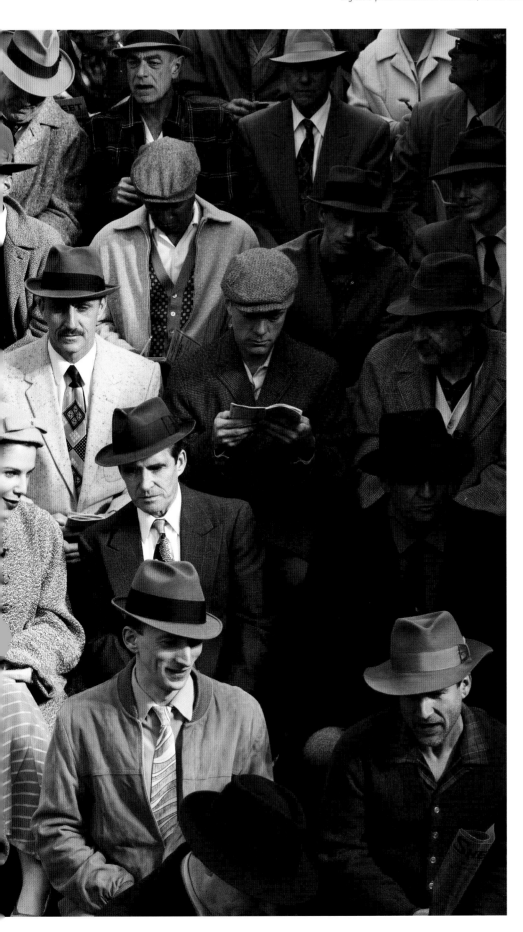

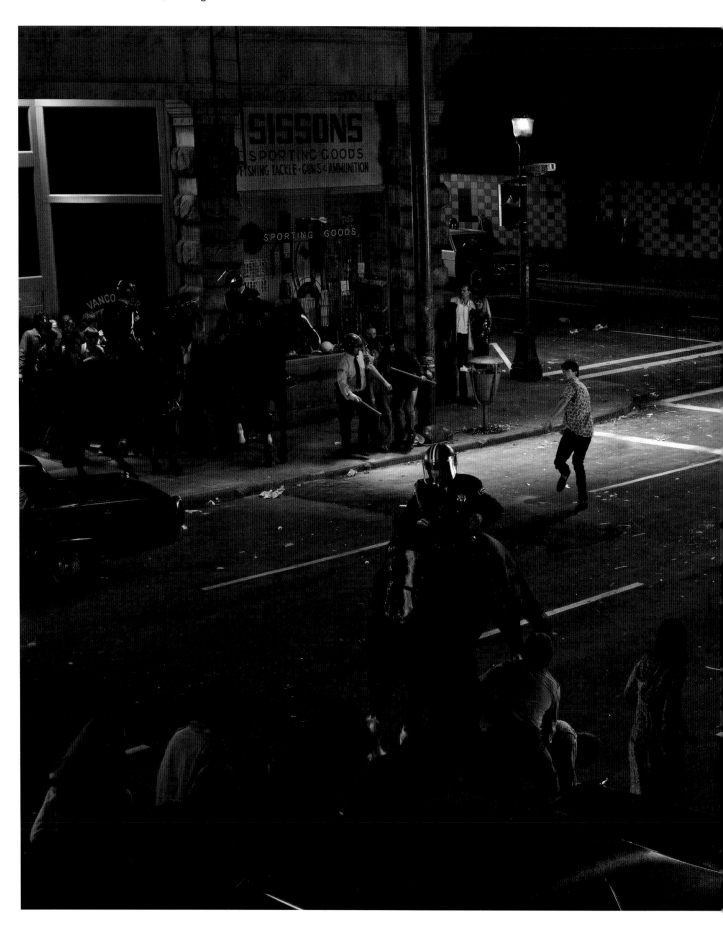

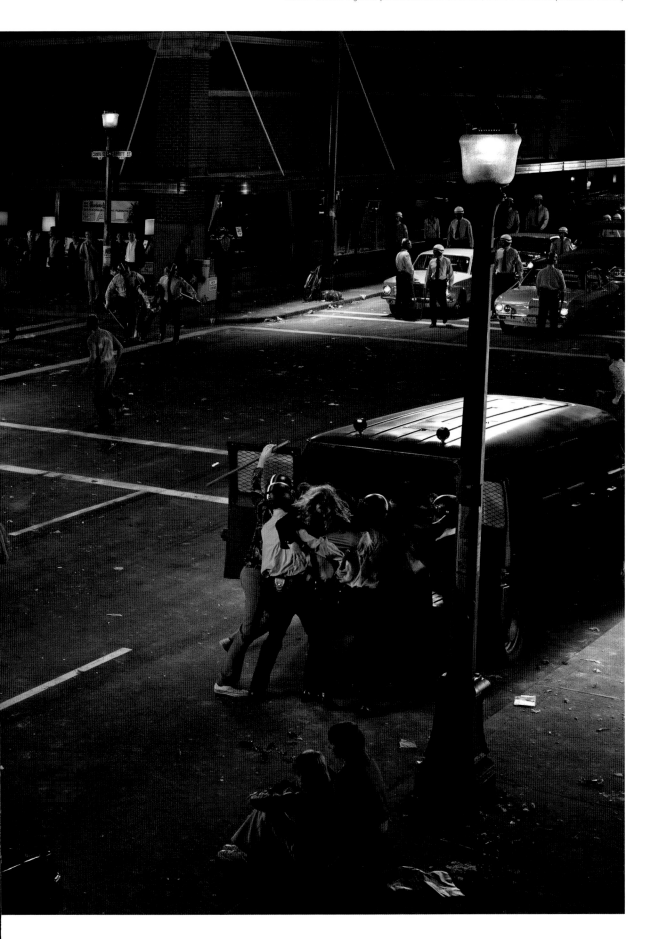

Edition version. Digital C-print mounted on aluminum, 114.5 x 70 inches (290.8 x 177.8 cm)

THE MOVING STILL
Stan Douglas's *Abbott & Cordova, 7 August 1971*

Nora M. Alter

Writing in the thirties, avant-garde filmmaker Hans Richter expressed his frustration with documentary filmmaking, declaring that a beautiful film of a rural landscape or a "romantic" village is highly problematic because it reveals nothing of the history and socio-politics of the region. He observes, "outwardly, everything looked quite picturesque, and there were plenty of opportunities for marvelous shots. But such a manner teaches one nothing about the object represented. And yet this is the 'documentarist''s usual style, this superficial reportage."[1] Richter is riffing on his compatriot Bertolt Brecht's by now infamous statement that "[a] photograph of Krupps or the AEG[2] yields hardly anything about those industries."[3] The challenge for Richter, and for countless subsequent image-makers working in the photographic realist medium of film, is how to "reveal" the history, the story, behind images whose indexical pull anchors them to a false truth based on appearances. Some early practitioners, such as Hannah Höch, found a solution in photomontage; others, like Aleksander Rodchenko, resorted to "photo-files"; later journalists, such as Henri Cartier Bresson, added texts to create photo-essays; and still other artists, like Martha Rosler in *The Bowery in Two Inadequate Descriptive Systems* (1974-75), posited both photography and text as insufficient forms for addressing social conditions. In short, the problems created by the essentially *pictorial* nature of the still photographic image led an increasing number of artists working in the genre of documentary to move away from the nineteenth-century medium of photography and toward the twentieth-century medium of film. Though still highly limited and riddled with its own problems of signification, the latter, with its time-based representations, was seen to be more adequate for depictions of history.

For Richter, one advantage of film (if executed properly) lay in the movement of the camera and skillful editing, which allow for a multiplicity of perspectives and narratives to emerge over the course of time. Richter continues, "[t]he cinema is perfectly capable in principle of revealing the *functional* meaning of things and events, for it has *time* at its disposal, it can contract it and thus show the development, the evolution of things ... The village, not as an idyll, but as a social entity."[4] Cinema was understood to record the passing of time, of events, whereas photography represented an isolated moment in history—a snapshot—always necessarily incomplete precisely because of its singularity in space and time. But both a film composed of discrete

1 Hans Richter, *Struggle for the Film: Towards a Socially Responsible Cinema*, trans. Ben Brewster (Aldershot, UK: Wildwood House, 1986), 46–47.

2 Krupps was a steel factory, Germany's oldest and largest corporation; AEG was Allgemeine Elektricitäts-Gesellschaft, Germany's equivalent of General Electric.

3 Bertolt Brecht, "Der Dreigroschenprozess, ein soziologisches Experiment," in *Gesammelte Werke in 20 Bänden* (Frankfurt am Main: Suhrkamp Verlag, 1967), Band 18, 161.

4 Richter, 47.

58

frames and an isolated photograph have the same effect: freezing or stilling time. André Bazin refers to this process as one of mummification in which the photographic process embalms a certain moment (or moments). What is recorded by the camera's eye is caught and suspended in a fixed temporal and spatial dimension—within each frame, movement is frozen or stilled. A reanimation process occurs when the individual frames are run through a projector and given the illusion of movement. Theories of analogue representation work from this conceptual premise; first, the still image of the photograph, then the moving image of film. Film is composed of multiple frames of still photographs which, when set into play, are perceived of as motion. With video there is a shift since the videotape is not composed of individual frames but rather of a modulation of scanning lines. And, during the past two decades, the advent of digital production has once again altered the way in which time, space, and movement are created.

With digitization, the temporal and spatial composition of film is radically altered. Instead of space and time being broken and separated into discrete units with a continuum activated through the mechanical process of editing and of the projector (cinema is often referred to as the "Last Machine"[5]), time, in Lev Manovich's words, "becomes spatialized" and "distributed over the surface of the screen."[6] No longer does a filmmaker or editor work with seemingly endless strips of celluloid footage that needs to be meticulously assembled into a relatively stable whole; rather, she edits on a computer in which images have been transformed into complex and condensed codes, structured by pixels and organized by software programs. The painstaking process of memory connected with assembling and tracking rushes gives way to a program in which everything is *always already there*, accessible by easy clicks and strokes of computer keys. In addition, full digitization makes obsolete cinema's prior dependence on the perfect shot, settings, lighting, and the like. Advanced colour correction and green-screen technology allow the filmmaker to make infinite adjustments and changes in background and details, much like a painter uses her palette to affect colour and tone, or her brush to eliminate or add objects at will. What the digital camera photograph does not necessarily have to bear is a close resemblance to how the final image will appear. Manovich refers to this metamorphosis in the cinematic process as a transformation from a "Kino-eye," to that of a "Kino-Brush." Digital photography and film now appear as a sub-genre of painting instead of as an index of reality.[7] In addition to adjusting how film is produced, the transition from analogue to digital has

5 Filmmaker Hollis Frampton coined the phrase, which was later adapted by Ian Christie in his excellent study of early cinema, *The Last Machine: Early Cinema and the Birth of the Modern World* (London: BBC Educational Developments, 1994).

6 Lev Manovich, *The Language of New Media* (Cambridge, MA: MIT Press, 2001).

7 Ibid., 295.

also homogenized previously discrete and disparate images and sounds. Put otherwise, whereas formerly a film might have been made as a 16mm print or a videotape and a record as a vinyl LP, digital media convergence transforms everything into the same computer data. In short, formal or technological variations become obsolete.

What might this mean for the representation of time and history in the context of the documentary photograph? To what extent do formal or technological details inform the way in which a work of art is conceptualized and carried out? Is there a relationship between the thematics of a work and whether or not it is carried out in analogue or digital form? Does the representation of history change? If the representation of movement and time was previously achieved visually—with sound, this is something entirely different—through the activation of a series of stills, with digital production, movement and time are contained within the composited image. The "time framed" of each discrete unit has been replaced with "framed time." As Garrett Stewart suggests in his consideration of the electronic image, "frame time gives way, on several fronts at once, to that flashpoint of mediation I am calling framed time. This is the spatialized configuration of time itself as in its own right a malleable *medium*."[8] Thus, no longer is it only film that has the capacity to represent spatio-temporal movement; now different times and spaces can be contained within the photographic still. The logics of ordering, from still to movement, become reversed and instead, we move from film (movement) back to the still image. How might such a reverse movement effect the representation of an event? Further, in departing from the "real" for the virtual, the digital loses its inherent documentary quality and instead enters into the poetic regime, a shift akin to history painting rather than recorded reality.[9]

Stan Douglas's public artwork *Abbott & Cordova, 7 August 1971* (2009) foregrounds the problem of historical representation and the task of rendering the social underpinnings of an historical event through the medium of photography when the undercurrent of the indexical pulls the photograph so strongly toward a truth based solely on surface appearance. This photographic work addresses the challenge by drawing on cinema's ability to multiply perspectives and narratives, and its capacity, through movement, to represent multiple moments in time and points in space. Although Douglas is an accomplished filmmaker, *Abbott & Cordova, 7 August 1971* is not a motion picture; rather, it is what I will call a "moving still."

Abbott & Cordova, 7 August 1971 is a monolithic double-sided image embedded in glass measuring fifty by thirty feet (13 x 8 metres) installed in the multi-use complex

8 Garrett Stewart, *Framed Time: Toward A Postfilmic Cinema* (Chicago: University of Chicago Press, 2007), 2.
9 Damian Sutton, *Photography, Cinema, Memory: The Crystal Image of Time* (Minneapolis: University of Minnesota Press, 2009), 4.

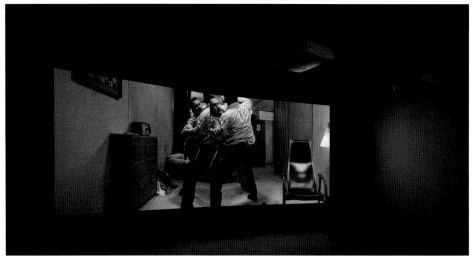

Stan Douglas, *Win, Place or Show*, 1998. Two-channel video installation; 204,023 variations with an average duration of 6:00 each. Installed at the Vancouver A Gallery, 1999. (Photo: Stan Dougla

erected on the site formally occupied by the Woodward's department store in Vancouver. Suspended above passersby in the newly configured atrium, this mural recalls over-sized images projected in drive-in movie theatres or the huge luminescent advertisements such as one finds in places like New York City's Times Square. *Abbott & Cordova, 7 August 1971* represents an historical event, of what is now known as the "1971 Gastown Riot" or the "Battle of Maple Tree Square," which involved a violent confrontation between hippies who were peacefully participating in a street festival and the Vancouver police. An "event" here is understood as an occurrence that produces a significant change in condition: there is a clear understanding of a before and an after. For Alain Badiou, an event must compel "the subject to *invent* a new way of being and acting in a situation."[10] An event is a pivotal moment or instance; it may be social, historical, personal, or even technological. Throughout his *œuvre*, Douglas has aimed to address "moments when history could have gone one way or another," noting that "[w]e live in the residue of such moments, and for better or worse their potential is not yet spent."[11] Thus, for example, Douglas's earlier *Win, Place or Show* (1998) is a mock television serial centred on two dock workers, Donny and Bob, who are confined to a tenth-floor, one-bedroom apartment that they share. The floor plan for their living quarters is derived from 1950s blueprints of a never-realized, low-income urban housing project designed for the working-class Vancouver neighbourhood of Strathcona. The initial project was part of the city's program for urban renewal, a process that would include razing the old neighbourhood and erecting apartment towers, row housing, and dormitories for the predominantly male dock workers. The project was never realized due, in no small part, to the organization of a powerful lobby of local citizens, which decried the proposed demolition of a neighbourhood in favour of anonymous, barrack-style housing. Douglas constructed the set for *Win, Place or Show* to replicate as closely as possible an apartment unit in one of these ill-fated high-rises.

10 Alain Badiou, *Ethics: An Essay on the Understanding of Evil,* Peter Hallward, trans. (London: Verso, 2002), 42.
11 Diana Thater, "Diana Thater in Conversation with Stan Douglas," in *Stan Douglas*, eds. Scott Watson, Diana Thater, and Carol J. Clover (London: Phaidon, 1998), 11.

For this earlier work, Douglas did not just signal an unrealized architectural site; rather, he highlighted another failed project in the public sphere: television. In its format, *Win, Place or Show* evoked television serial dramas. More specifically, Douglas shot the scene in the style of a 1968 Vancouver-produced CBC series, *The Clients*. Slightly experimental in style and form, this series enjoyed only a short run, ultimately failing because the "concise parables did not abide by conventional rules of television drama: the employment of long takes, the absence of master shots, and the inarticulateness of leading characters were among its signature features."[12] *The Clients,* in other words, was not successful because it tried to provide an alternative to the hegemonic style of North American broadcasting. But there is more; *Win, Place or Show* was a highly sophisticated double screen installation, a six-minute-long sequence shown in a continuous loop. Shot from twelve different camera angles, and cut together in real time by a computer program capable of generating an almost endless series of montages, every sequence repeats differently. The exceedingly high production quality of the installation, as well as the computer generated variations, foregrounds the technological aspects of work. In his conversation with Diana Thater, Douglas remarks that "[w]hen they become obsolete, forms of communication become an index of understanding of the world lost to us."[13] *Win, Place or Show* references television at a point in history when, as a medium for audio-visual communication, it was unparalleled in the field of mass communications. Through developments in cable, satellite, and video in the eighties, however, the Internet and advances in computer technologies emerged in the nineties, leaving television forever fundamentally changed and nearly obsolete.[14] The concept of a potential public united by a common experience, i.e., receiving and watching more or less the same broadcasts, has been lost, replaced by an isolated form of spectatorship defined by the complete freedom to decide what to watch and when. *Win, Place or Show* signals precisely this shift from analogue to digital production and distribution as well as its impact on the entertainment industry.

More recently, Douglas's *Le Détroit* focused on the urban deterioration of Detroit, once the fourth largest city in the United States. His camera reflects the decrepit and degraded present of an abandoned project. *Le Détroit* (whose French title refers to the naming of Detroit as "the strait," a description of Detroit's location on the Detroit River linking Lake St. Clair and Lake Erie) was made in 1999 and constitutes a farewell to the twentieth century. A strait is a liminal space located between two

12 Stan Douglas's project description of *Win, Place or Show.*
13 Thater, 9.
14 For a particularly insightful study on the impact of the innovations on film production see Timothy Corrigan, *A Cinema Without Walls: Movies and Culture After Vietnam* (New Brunswick, NJ: Rutgers University Press, 1991).

larger bodies of water; it is a channel for a passage or transition—in this case, from one century to the next. *Le Détroit* is composed of a double-sided screen on which two negative film images in black-and-white are projected, nearly cancelling each other out. The work's barely perceptible timing delay produces an eerie spectral effect on the already shimmering, shadowy greys of the image. This ghost-like effect of a present haunted by a past records the passage of time from one century to the next; as an installation, *Le Détroit* becomes a metaphorical strait across which the images pass from one space to the next. As in all of Douglas's work, the social, historical, political, and technological are inextricably entwined. Echoing Walter Benjamin's claim that any aesthetic innovations, such as photography, can never be separated from their social underpinnings, Douglas's practice actualizes and brings to the fore such connections.

Abbott & Cordova, 7 August 1971 performs a similar grafting of socio-historical content onto the form and mode of its own production. Douglas's mural at once references two pivotal moments in history: 1971 and 2009-10, when the complex opened. The Gastown neighbourhood in which the piece is installed was formerly populated primarily by working-class families. In the late sixties and early seventies, young hippies gradually moved into the area, often squatting in abandoned commercial properties; their presence caused tension with the more conventional residents. The event represented in Douglas's work was catalyzed by a peaceful "smoke-in" in late summer 1971. The police were called to disperse the crowd and break up the gathering. However, their interaction with the hippies became violent, and a riot quickly erupted. What later emerged was that, instead of a spontaneous response to break up a crowd, the police intervention had been carefully planned and strategized to the extent that undercover cops, disguised as hippies, had infiltrated the peaceful group in order to

Stan Douglas, *Le Détroit*, 1999. Two-channel anamorphic 16mm film installation; 6:00 each loop. Installed at 90 Annabella Street, Winnipeg, Manitoba, sponsored by Plug In Gallery, 2001

Stan Douglas, *Vidéo*, 2007. HD video with stereo sound. Installed at David Zwirner, New York, 2008. (Photo: Cathy Carver)

instigate clashes with the police.[15] Douglas meticulously restages this event in his comprehensive, expansive image.

Abbott & Cordova may likewise be viewed as part of a larger rubric from the same year loosely called "Crowds and Riots" that focus on events of "police riots" in which "the very actions of the police generate the kind of violence that they are presumably meant to contain" (Alberro/Douglas 2011). These were initially presented in 2008 at the New York gallery David Zwirner, in a show entitled "Humor, Irony, and the Law," and include *Powell Street Grounds, 18 January 1912*, and *Ballantyne Pier, 18 June 1935* (both 2008). The historical subject of the former C-print was police officers breaking up a crowd of unemployed that had been organized by Wobblies to address labour concerns; *Ballantyne Pier* addresses a 1935 labour action during which striking dock workers clashed with police who resorted to extreme forms of violence to disperse the demonstrators. Although thematic affinities emerge in these works in terms of their form, they radically differ in their intended audiences. The C-prints were produced as large-scale photographs to be mounted on the wall of a commercial gallery and viewed by the narrow field of art-world cognoscenti. The final product of *Abbott & Cordova*, however, was designed for a broader and more random, and hence less predictable, group of Vancouverites who enter the multi-use Woodward's atrium to go home, go to work, go shopping, attend classes, engage in entertainment activities, and the like. The two intended audiences are radically different: the former is a relatively homogeneous, small controllable elite who are granted permission to enter a private space of a gallery; the latter is an everyday public from all walks of life.[16] The local scene represented in *Abbott & Cordova* interacts with them in a very different way than it does installed in its diminutive form in a private space 3,000 miles away in another country.

In order to make *Abbott & Cordova*, Douglas painstakingly researched the event,

15 A similar tactic was used by pro-Mubarek forces in Egypt who paid individuals to try and inject violence into the peaceful demonstrations in Cairo in February 2011 and thereby legitimate a lethal military response.

16 The bottom line that galleries are indeed private cannot be ignored as the 2010 incident at New York's Gagosian Gallery reminds us, when the employees of Gagosian ordered the forcible removal of visitors (members of an organization called U.S. Boat to Gaza) to an Anselm Kiefer show.

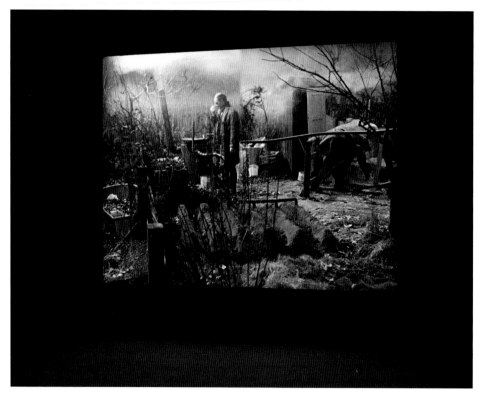

Stan Douglas, *Der Sandmann*, 199[...]
Two-channel 16mm film installat[...]
9:50 each loop. Installed at the
Staatsgalerie Stuttgart, Germany,
2007. (Photo: Stan Douglas)

delving deep into archives to study newspaper clippings, stories, and images. He then built a Hollywood-like set in a parking lot and re-created the event using period props and authentic paraphernalia from the late sixties and early seventies. Just like in a studio production, everything was re-created for, in Siegfried Kracauer's term, this "Calico World"; the crew built a street, sidewalks, and flats of the buildings.[17] Verisimilitude was strived for down to the last details such as posters announcing rock bands, discarded newspapers, and other events dated to 1971. Actors were chosen, and the scene was directed. Roles were carefully cast and performed, and multiple takes resulted in a databank of images, of which Douglas selected fifty to be digitally composited into the single picture, *Abbott & Cordova, 7 August 1971*. The process of constructing a film set, making a movie, and then creating a photographic image out of that process is also an event. As Douglas explains, each of his projects involves both a back-story and a sensible model; in this case, the event occurs in the story (the Gastown Riot) as well as in the mode of production—film. And yet, one may ask why, when digital postproduction allows for the possibility of changing, and altering, the final product, did Douglas resort to an almost old-fashioned mode of pre-production? One explanation may be that he is also recording the passing of film, just as earlier, in *Win, Place or Show*, he signaled the demise of a certain type of television, and in *Der Sandmann* (1995), he relied on an early feature of trick photography—compositing—to stress how the old wipes away the new as the new wipes away the old. Again echoing the theories of Benjamin, of central concern to Douglas is how ideas are intimately

17 Siegfried Kracauer, "Calico-World," in *The Mass Ornament: Weimar Essays*, ed., trans. Thomas Y. Levin (Cambridge, MA: Harvard University Press, 1995), 281–88.

linked to modes of representation. As certain models become obsolete, so too do ways of thinking. New codes of representation bring about new patterns of understanding. What immediately strikes viewers about *Abbott & Cordova* is the depth of focus present in all aspects of the image. This effect—a result of the high density of the fifty composited images—would have been impossible to achieve with analogue systems, pointing to the degree of media convergence that has been reached in the digital era.

Douglas's resulting image is of the intersection of the two streets (hence the title) at night. Three antiquated street lamps illuminate the scene. The intersection itself, or middle of the "photograph," is relatively empty, populated only by three isolated figures crossing at a diagonal; their backs turned to the camera, one young man looks over his shoulder. Notably, most activity is concentrated on the margins of the photograph. In the immediate foreground, a mounted policeman assails a group of ten people pressed back against a black convertible with its top up. Across the street, two additional police on horses push a crowd back against a storefront window, preventing them from entering or crossing the middle of the street. In the right foreground, two uniformed police violently push a struggling, long-haired protestor into a black paddy wagon. This sector of the image becomes disconcerting as soon as we notice two additional hippie figures on each side of the van's doors, apparently assisting the policemen. Upon closer inspection, we see that while the "prisoner's" hair flails wildly in struggle, in contrast, theirs is contained under protective helmets and, further, that the man on the left wields a baton which is caught mid-air as it descends on the unlucky victim. What does this curious detail mean? As our eyes travel up the photograph and across the street, we find, on the opposite corner, a policeman and two similarly clad "hippies" with protective headgear and batons. As we follow the policeman's gaze across the street to the upper right of the image, we find two more policemen dragging another arrestee, presumably to be packed into the van. To their left, walking away from the scene with their backs to the camera, are two young men dressed in innocuous blue jeans and loose shirts, their heads covered in the same blue helmets. Their calm, authoritative demeanour as they strut down the middle of the street stands in strong contrast to the panicked and distraught gait of the first three figures described who are caught by Douglas's lens in the act of fleeing. Instead, these self-possessed individuals are clearly in control, their official blue headgear linking them to the other four individuals still assisting the police. For these two, their work has been completed. All six of these figures historically reference the undercover plainclothesmen who the police used to infiltrate the "smoke-in" and to help incite the riot from within. The margins of the photograph, which are marked by the streets, are populated with

Stan Douglas, *Hors-champs*, 1992. Two-channel video installation; 13:20 each loop. Installed at the Württembergischer Kunstverein, Stuttgart, Germany, 2007. (Photo Stan Douglas)

passersby who observe the confrontation: one couple sits on the curb, another stands at the street corner, some emerge out of a bar. They are, as Douglas explains, "working-class older men who watch the action as if it were street theatre. That's something I noticed in photographs and film footage at the time. People who couldn't be outwardly identified as hippies didn't feel threatened by the police action" (Douglas 2011). In short, we find a theatre or spectacle in the round consumed by passive witnesses who watch the abuse and violence unfold but do nothing about it. A viewer of *Abbott & Cordova*, looking up at the work from the Woodward's complex, would be similarly positioned on the margins outside of the action—sutured into the perspective of the spectators in the image. The two types of viewers are then brought together across time and space to converge and perhaps question their role in silently witnessing, accepting, and consuming abuse.

Abbott & Cordova depicts the unfolding of a historically specific event—the Gastown riot; however, metonymically, it references a particular climate of riots prevalent in North America at that time. A riot, defined as a relatively spontaneous civil disorder, in contrast to a demonstration, is disorganized and unpredictable. What happened on the corner of Abbott and Cordova was relatively unimportant in light of all the other riots and demonstrations that were taking place in the Western world in the late sixties and seventies, and yet it remains significant for having been symptomatic of them. It was precisely this climate of civil disobedience that enabled the Gastown riot to take place. In an interesting parallel to the composition of the image that focuses on the margins, the actual intersection depicted in Douglas's scene was not at the centre of the riots but on its periphery. And arguably, while very important for an urban history of Vancouver, the Gastown riot, within the larger Western perspective of youth demonstrations such as May '68 or the Levitation of the Pentagon, is relatively minor. The event is related to, and certainly part of, an era of protest and demonstration, but is located on the margins or peripheries of those events. As with much of his work,

Douglas uses a "minor" moment in history to point to a much larger history.[18] For example, his double-sided projection, *Hors-champs* (1992), calls attention to free jazz while, at the same time, commenting on the African-American expatriate community living in Paris, as well as the French Communist Party. The periphery thus comments upon and maintains the centre and vice versa in a centrifugal/centripetal relationship.[19]

The Battle of Maple Tree Square is significant on a number of levels beyond the initial display of police brutality, for it initiated changes in law and policies that remain in place today. Prior to this event, Gastown was zoned as a partially residential neighbourhood, thereby permitting squatters and others to take up residence; in the aftermath of the riot, the zoning was quickly changed to purely commercial, thereby transforming it into a dysfunctional zone. The subsequent decline of the neighbourhood into a seedy skid row area infested with drugs is attributed to this change in zoning. In the first decade of the twenty-first century, further attempts were made to gentrify the area, including the development of a former department store, Woodward's, into a multi-use building, which includes low-income housing. It was for this site that *Abbott & Cordova, 7 August 1971* was commissioned. The space, however, is no longer public but has become completely privatized, subject to the rules, regulations, and control of private interest. The transformation from public space to private zone is a global phenomenon as corporations purchase ever-greater swathes of land, some located in prime urban real estate areas.[20] The implications of this transformation are far-reaching. After the Gastown riot, the police were held accountable for the ensuing violence. Their calculated and aggressive response was censored, and, as public servants, they were warned not to harm denizens in the future. Precisely because the police force, like the military, is supposed to serve and protect (although abuses are rampant), in theory, they are still accountable for their actions. With the transformation from public to private, a shift occurs, and, as Douglas observes, "certain areas are designated private property and patrolled by private security companies which, unlike the police force of 1971, are not answerable to citizens" (Alberro/Douglas 2011). Of course, on a much larger scale, the same phenomenon persists as private enforcement militia such as Blackwater are employed with deadly consequences in countries such as Iraq. From small, innocuous gated communities to full-scale insurrections, the detouring of laws protecting citizens' rights is assisted through privatization. There

18 I am using "minor" here explicitly referring to Deleuze's concept. See Gilles Deleuze and Félix Guattari, *Kafka: Toward a Minor Literature*, trans. Dana Polan (Minneapolis: University of Minnesota Press, 1986).
19 See Trinh T. Minh-ha, *When the Moon Waxes Red: Representation, Gender, and Cultural Politics* (New York: Routledge, 1991).
20 Think, for example, of the SONY Center in the Potsdamer Platz in Berlin.

Stan Douglas, *Subject to a Film: Marnie,* 1989. 16mm film installation; 5:15 each loop. Film still

is, however, another side to this story, for *Abbott & Cordova* was commissioned by the private developer of the Woodward's complex, thereby allowing Douglas a certain amount of freedom. For had it been sponsored by the city, still eager to bury that unsavory history, it is likely that such a provocative image would have been censored.

Douglas photographed the dramatic scene of *Abbott & Cordova, 7 August 1971* from a slightly elevated angle looking down. This perspective gives the impression not only of a detached observer surveying the events from a second-floor window (the actual positioning would have been from a rooming house in which many of the hippies hung out at the time) but also of a type of surveillance camera that is now all-pervasive in both private and public spaces alike. Today, as we live in an unprecedented era of surveillance, all such "public spaces" are heavily monitored with cameras triggered by movement and "trained" to record every angle of space. The extension of military technologies to the monitoring and management of urban environments connects to Michel Foucault's theories of biopolitical regulation. Photography was the medium of police surveillance (Bertillonage) from the nineteenth century to the present, used to track criminals and to fill files on individuals. The theme of surveillance emerges in several of Douglas's works, including his homage to Beckett titled *Vidéo* (2007), in which a video camera tracks and follows a young North African woman through the projects outside of Paris, and *Subject to a Film: Marnie* (1989), which recreates a pivotal scene in Hitchcock's film in which we witness the lead character's thievery. Today, just as booked criminals are photographed, so too are demonstrators and protestors, such as those in Seattle at the WTO protests, recorded in order to monitor their activities and to identify them as potential troublemakers. *Abbott & Cordova* recalls that history as it projects into the future. But in its overt use of the digital format, the work also reminds us how we, as subjects, have been transformed into bits of data sorted and stored in databanks ready to be accessed at any moment. We are tracked as consumers, as travellers, as patients, as commuters, as students: our movements and patterns recorded and ordered. To be anonymous without a digital trace has become as difficult as existing without a shadow.

Abbott & Cordova connects to several other recent works by Douglas. Seven years earlier, he made *Every Building on 100 West Hastings* (2001), a photograph depicting the entire 100 block of West Hastings Street in Vancouver.[21] The street and its immediate neighbourhood had degenerated from being an alternative community populated by artists to one overrun by crime, populated by drug dealers and homeless people. In Douglas's words, the photograph "depicts the neighbourhood as it was left to go fallow

21 The title references Edward Ruscha's *Every Building on the Sunset Strip* (1970).

Stan Douglas, *Detroit Photos: Abandoned Apartment Building*, 1997–98. Chromogenic print. Image dimensions: 18 x 36 in

until it became commercially exploitable again" (Douglas/Alberro 2011). Interestingly enough, *Every Building on 100 West Hastings* depicts the buildings on the south side of the street. This is because the north side was almost entirely occupied by the abandoned building dating from 1903 that formerly housed Woodward's department store, a once splendid and thriving shopping mecca. Like so many of these establishments from the first half of the twentieth century, as suburbs grew and convenient shopping malls sprang up, it became increasingly impossible to remain financially viable. In addition, the re-zoning of the area because of the Gastown riot led to the neighbourhood's deterioration. In other words, the event depicted by Douglas in *Abbott & Cordova* uncannily loops forward and backward to the bleak scene photographed in 2001. When Woodward's closed in 1993, the 100 block of West Hastings, which had undergone a brief renaissance, took a turn for the worse and became skid row. *Abbott & Cordova* was commissioned for the renovated Woodward's complex that now includes condos, stores, community spaces, subsidized housing, an extension of Simon Fraser University, daycare, and more. The multi-use complex is a full-scale project and product of urban gentrification carried out by both private and municipal partnerships.

Douglas's public artwork *Abbott & Cordova, 7 August 1971* stands as a piece of history. Douglas asserts [that] "the photograph has produced an image of something that could easily be forgotten, it consolidates hearsay into a picture that will hopefully produce more hearsay and a conversation about history" (Alberro/Douglas 2011). To that extent, it connects back to documentary whose etymological roots are to teach and to warn. In its composited form, Douglas's photograph restages and combines a multitude of images created out of a series of incidents and fractions of seconds, resulting in a single whole, self-consciously and self-reflexively composed of fragments. As a result, the angles in the image are at times impossible, and the totality of the picture is difficult to take in. But it is not enough to acknowledge the complexity of the image itself; we need to recall the architecture for which this public mural was conceived as well. Meant to be viewed from different vantage points, it speaks to individuals looking up at it while crossing the atrium at street-level, casting a glance across it from a second

or third-floor apartment, or gazing down at it from the roof-top.[22] Thus, *Abbott & Cordova* unfolds to the viewer in bits and pieces. And because of its high density and its fifty different embedded shots, it resists producing a single view that is any more or less distinct—each fragment is a hermeneutic monad. True to its Romantic roots, each fragment is charged, and each is a crystallization of an event. Formally, one feature of digital composition is its potential as a portal or interface, and we could imagine the possibility of zooming in on and clicking on various parts of the mural to enter into the different individual histories referenced.

Abbott & Cordova, 7 August 1971 harkens back to Douglas's earlier excurses into public art: *Television Spots* (1988) and *Monodramas* (1991), short video sketches that were inserted into public television broadcasting. In both content and form, they were markedly different, calling attention to alternative possibilities for television. One characteristic of these works was their length—usually between thirty and sixty seconds—thereby employing a very condensed form to deliver a punch. Prefiguring *Abbott & Cordova*, these earlier works consist of fragments of narratives inserted into a much larger media flow just as fragments are composed together into the whole of *Abbott & Cordova*. In both instances, what is at play is a form of condensation or reduction of information into one image—or in this case into fifty different images composited into one. Because of all the different images or scenes, it does not conform to the work of a typical billboard but is rather like a mural or a painting by Hieronymus Bosch in which multiple temporal and spatial events are depicted in a single plane. This multiplicity of scenes contained and reconciled within a larger whole is similar to how Henri Bergson characterizes the process of memory as one of "contraction," in which images from the past are put together to form a single memory. They remind the viewer of what took place on this spot forty years ago and what might take place again. For, in the words of Benjamin, the spectator regarding a photograph "feels an irresistible compulsion to look for the tiny spark of chance, of the here and now, with which reality has, as it were, seared the character of the picture; to find that imperceptible point at which, in the immediacy of that long-past moment, the future so persuasively inserts itself that, looking back, we may rediscover it."[23]

The fragments form a narrative that is meant to provoke the passersby into thinking about what happened and their present condition as autonomous subjects. If earlier forms of photographic social commentary were performed through the reliance

22 To that extent it functions like the behemoth multi-story television screen installed in the CNN Center headquarters in Atlanta, visible and audible from every location.

23 Walter Benjamin, "A Short History of Photography," *Screen* (1972) 13(1): 5–26. (Originally published 1931 in *The Literarische Welt*.)

of captions and texts, such as in photojournalism, Douglas achieves the same objective by compositing different moments in time and space within one image—a moving still. If music, another time- and movement-based medium, was used as a compositional strategy with/in some of Douglas's earlier work, here it has been replaced by another time-based medium: film. Writing about the form of the essay half a century ago, Theodor Adorno reflected that it "thinks" in fragments. For Adorno, the essay was the form of political critique par excellence, one that did not seek conclusions but was open-ended and produced dialogue, not judgments.[24] Much in the same spirit, Douglas's work may be viewed as an image essay—albeit without text—that through its fragments produces a conversation with the present and the future that is interrogative. Douglas does not make us aware of the present by any anachronistic inserts; rather, he signals the present by the very digital format used, one that dramatically, and self-reflexively, calls attention to its form, hence underscoring that memory and history will be stored (and possibly erased) as data bytes in the future.

Stan Douglas, *Television Spots: Funny Bus,* 1988. Stills from a video for broadcast television. 0:15

24 Theodor W. Adorno, "The Essay as Form," *Notes to Literature,* vol. 1, trans. Sherry Weber Nicholsen (New York: Columbia University Press, 1991), 3–23.

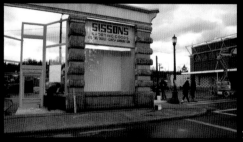

1

2, 3

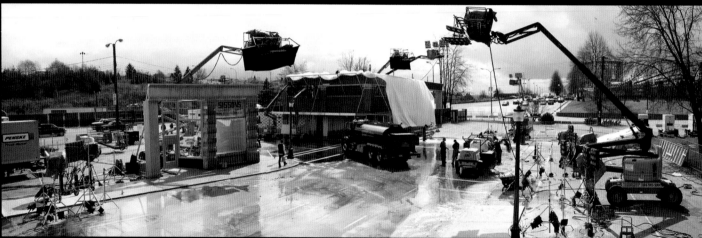

4

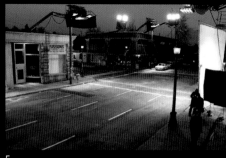

5

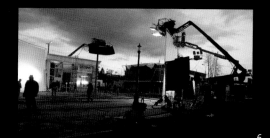

6

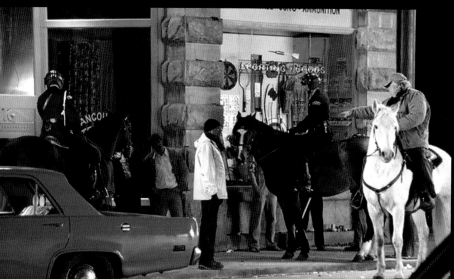

7

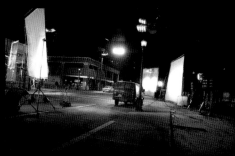

8

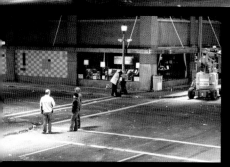

10

Production stills, *Abbott & Cordova*,
April 10 and 11, 2008

1, 2, 3, 5, 6, 8, 9, and 10:
Photos: Linda Chinfen

4: Photo: Stan Douglas

7: Photo: Rosamond Norbury

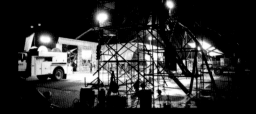

1

2

3

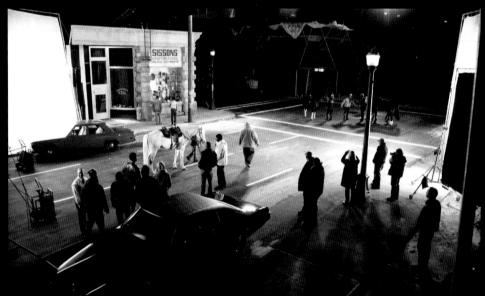

4

5

6

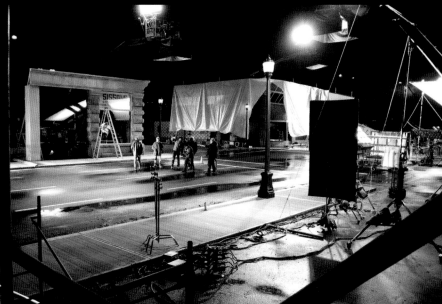

7

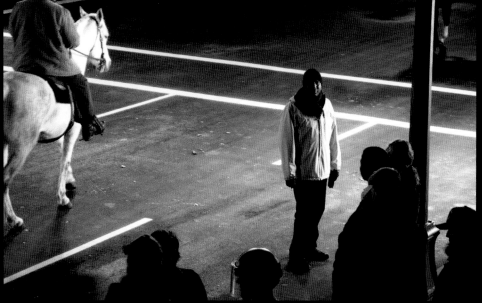

Production stills, *Abbott & Cordova,* April 10 and 11, 2008

1, 2, 3, 5, 6, 7, and 9: Photos: Linda Chinfen

4 and 8: Photo: Rosamond Norbury

9

PERFORMING PHOTOGRAPHY
AFTER FILM

Sven Lütticken

One cannot simply describe Stan Douglas as a filmmaker, or as a photographer—or even as a filmmaker and photographer. He works in these media, but perhaps even more so he works in between them (and others). Clearly, then, a discussion of Douglas's use of these media is central to any analysis of his work; after all, these are not neutral vehicles for some predetermined ideal content, for some quasi-Platonic ideas or concepts. On the other hand, neither should one think of the works as being completely derived from the properties of these media. If the first (idealist or conceptualist) approach would seem to be completely discredited, the second (seemingly materialist) approach still rears its head from time to time. It tends to turn the work of art into a seamless whole, since it accepts no "apart from" the medium, no surplus, no fissures or conflicts within the work of art.[1] But the media technologies employed by Douglas are themselves already fractured and striated; they are composed of technological and cultural layers, and Douglas's formal or structural decisions seem intent on unraveling, rather than glossing over, the composite nature of these media.

To present Douglas's works as seamless entities would be to regress to an idealist aesthetic that states that form and content coincide completely in genuine works of art. Hegel's argument in *Science of Logic*—that content is nothing but the *transformation of form into content* and vice versa—was an important challenge to simplistic distinctions between a pre-given content and form as something imposed on it. Yet Hegel's lectures on aesthetics would curtail the dialectic of form and content by glorifying classical Greek art as having reached the perfect harmony of form and content, with later art representing a long decline because post-antique, Christian content was beyond embodiment in physical form.[2] Adorno's *Aesthetic Theory* can be seen as an extended argument against the idealist fetishization of harmony, of the work of art as a seamless symbol. Adorno deconstructs this idealist dialectic, describing form as "sedimented content" and noting that "those traits of radical art that have caused it to be ostracized as formalist are all caused by content twitching physically in it, content that has not a priori been clipped by conventional harmony."[3] In other words: with Beckett or Mondrian (but not, say, Vasarely), form is shaped by heteronomous forces, by historical

1 Concerned with what he sees as the refusal of those whom he—in a charmingly patronizing gesture—calls "sensitive critics" to come to terms with "the love affair between Stan Douglas and machines," George E. Lewis overreacts by claiming that there is no "apart from" technology in Douglas's work. However, there clearly *is* an "apart from"—not, obviously, in the humanist sense of some essential content that remains unchanged by the technology, but in the form of elements that are only partly transformed through it, that resist complete assimilation and transmutation. George E. Lewis, "Stan Douglas's *Suspiria*: Genealogies of Recombinant Narrativity," *Stan Douglas: Past Imperfect, Works 1986–2007* (Staatsgalerie Stuttgart/Württembergischer Kunstverein Stuttgart, 2007), 53.

2 G.W.F. Hegel, *Enzyklopädie der philosophischen Wissenschaften I: Wissenschaft der Logik,* Werke vol. 8 (Frankfurt am main: Suhrkaom, 1986), 265.

3 "*Vollends die Züge der radikalen kunst, derentwillen man sie als Formalismus ostraziert hat, stammen ausnahmslos daher, dass Inhalt in ihnen leibhaftig zuckt, nicht vorweg von gängiger Harmonie zurechtgestutzt wurde.*" Theodor W. Adorno, *Ästhetische Theorie* (Frankfurt am Main: Suhrkamp, 1973), 218. Author's translation.

Stan Douglas, *Suspiria*, 2003. Single-channel video installation; infinite permutations. Installed at Documenta 11, Kassel, Germany, 2002

experiences and exigencies. For all its hyper-controlled appearances, good modernism twitches and itches. Its content manifests itself in forms whose origins cannot be explained by formalist ideologies. However, referring to the Warburg Institute and to Benjamin's book on the Baroque *Trauerspiel,* Adorno also concedes that more narrowly defined "content," such as iconographical motifs, should not be neglected; such motifs are "supports of substance [*Gehalt*] against the pressure of subjective intention."[4]

In the 1960s and 1970s, structuralism attempted to do away with the dialectic of form and content for good by analyzing works of art as differential signifying structures. Permutational works by Stan Douglas such as *Suspiria* or *Journey into Fear* can be seen as structuralist exercises. Their programmed, rigidly aleatory sequences are not externally imposed on some primordial layer of "content," and yet the work does not dissolve in its structure, does not coincide with it. To think that there is no outside, no supplement, was precisely the idealist regression inherent in some less sophisticated versions of structuralism in the humanities, which assumed that the work would become transparent with the right theory in hand. One of the fundamental experiences that one can have when confronted with Stan Douglas's works is that they are both excessively rich and reticent; that they come with a surplus that may also, depending on the viewer and the situation, be experienced as a lack. If you get the references to Melville's *The Confidence-Man* in *Journey into Fear* but not to the various *Journey into Fear* films, the work takes on a different character than if the reverse is the case. Douglas's short essay on the piece, which develops some of its sources and its implications, may be seen as a supplement that is actually part of the piece that it supplements—part of its surplus, which is to say, of its lack.[5]

4 "*Die inhaltlichen Momente sind Stützen des Gehalts wider den Druck der subjektiven Intention.*" Adorno, *Ästhetische Theorie*, 219. Author's translation.

5 Stan Douglas, "Journey into Fear" (2001), in *Stan Douglas: Journey into Fear* (London: Serpentine Gallery, 2002), 135–138.

Something similar can be said of *Abbott & Cordova, 7 August 1971*, which depicts the violent disruption of a public protest by the Vancouver police. Douglas links this incident to the subsequent transformation of the Gastown area into a purely commercial district.[6] It is self-evident that this complex history is not self-evident from the photograph, which can however be an occasion for fleshing out this history, similar to the way in which *Every Building on 100 West Hastings* was explored in a previous publication.[7] Such historical analyses can be said to stand apart from Douglas's use of media and technologies, but they nonetheless respond to something that is both integral to and, perhaps, not fully integrated in the work. The same can be said of the media history or media archaeology that Douglas practices with his work: like Melville's confidence man, it is never fully present.

After the Cinema

Abbott & Cordova, 7 August 1971 is part of Douglas's photographic series *Crowds & Riots*, which also includes photos such as *Hastings Park, 16 July 1955* (2008). These works differ from most previous photographic work by Douglas, which depicted sites related to his films—crumbling Detroit, German allotment gardens, architecture in Havana. However, *Abbott & Cordova,* while also existing as a "regular" photographic print, functions as a public art piece on a monumental scale, lit from behind like a back-projection in film production, and the staged and composited nature of the photo obviously has filmic connotations. The same goes for the production process; the set and the shoot have been compared, by Douglas and by critics, to film sets and shoots. Vancouver is the third-busiest location for film shoots in North America, with the city usually functioning as a more or less generic American backdrop; Douglas in fact built a backdrop of a Vancouver street corner to excavate some of this image-city's less visible historical layers.[8]

Stan Douglas's work is part of a context in which Modernist definitions of medium-specificity seem as anachronistic as grand utopian claims about the fusion of media into a *Gesamtkunstwerk*. At different moments in the nineteenth and twentieth centuries, both the "purification" of artistic media or their combination in

6 See the interview with Stan Douglas by Alexander Alberro in this publication.
7 Reid Shier, ed., *Stan Douglas: Every Building on 100 West Hastings* (Vancouver: Arsenal Pulp Press and Contemporary Art Gallery, 2002).
8 On Vancouver as film location, and on Vancouver in an event- and image-driven economy in general, see Alissa Firth-Eagland, "Invisible Becoming," in *Momentarily: Learning from Mega-Events,* eds. Bik Van der Pol, Alissa Firth-Eagland and Urban Subjects (Vancouver: Western Front, 2011), 5-13.

80

quasi-organic totalities seemed to promise relief from capitalist instrumentalization—the former, because it seemed to offer an antidote to the kitsch of the culture industry, and the latter, because it suggested the possibility of reversing the alienation and fragmentation of capitalist production by integrating not only various arts, but most importantly art and life.[9] But the grand socio-artistic dreams of Wagner, of the Bauhaus, or indeed of Fascism have been replaced by pragmatic media integration through digitization. The media retain vestiges of specificity, but in many ways they survive as cultural codes or layerings of conventions more than as media in the old sense, with a specific material basis.[10] Douglas's practice is marked by an engagement with the theatre, especially Beckett, but this theatre is impure and partly shaped by other media, as shown by a work such as *Vidéo*, which refers to Beckett's *Film*. Film, of course, is one major source of references for Douglas's work, and some of his work of the late 1980s and early 1990s can be seen as having inaugurated a wave of "cinematic" art in galleries and museums.

However, this cinematic art is a manifestation of a *post-cinematic* regime in which the cinema has lost its cultural dominance and in which cinematic tools and tropes find refuge in the art world. Often, cinematic art uses the very medium that brought film down: video is habitually employed to recycle film clips. When Douglas employs video, in works such as *Monodramas*, *Hors-Champs*, *Suspiria*, and *Vidéo*, the works both reflect and reflect on the medium and its complex historical role, including its relation with film; in *Suspiria,* the colour of NTSC images evokes the saturated technicolour of Dario

Argento's film of the same name. In works in which filmic references are more prominent, such as *Journey into Fear*, or *Inconsolable Memories*, Douglas's medium of choice is film rather than video, but this is film as remediated by post-cinematic technology: the film loops are accompanied by a soundtrack which, thanks to computer programs tailor-made for these pieces, produces a staggering number of dialogue and voice-over permutations, resulting in near-endless films that could not be more different from standard features. A charade on a cargo ship that references both

Stan Douglas,
Inconsolable Memories,
2005. Two-channel
16mm film installation;
15 permutations, 5:39
each loop. Film still

9 See Jens Schröter, "The Politics of Intermediality," www.acta.sapientia.ro/acta-film/C2/film2-6.pdf
10 Rosalind Krauss focuses on the "layers of conventions" inherent in a medium in *"A Voyage on the North Sea": Art in the Age of the Post-Medium Condition* (London: Thames & Hudson, 1999).

films called *Journey into Fear* and Melville's *The Confidence-Man* in order to reflect on the transformations of capitalism in the last half-century, Douglas's *Journey into Fear* is literally unwatchable: it is impossible to see the film in its entirety.

We are dealing, then, with a post-cinematic temporality that is connected to television rather than film. Like *Journey into Fear*, television goes on and on and on. *Suspiria,* made for documenta 11 in Kassel, makes this latent "televisual" nature of much of Douglas's work explicit. Employing real television technology, *Suspiria* consisted of a continuous live video feed from the dungeon-like spaces underneath the Hercules Moment in the park of Schloss Wilhelmshöhe in Kassel; these images were mixed with footage recorded in a studio of scenes based on Grimm fairytales, with some Marx thrown in, permutated by a computer program in such a way that they became ever more disjointed through the course of time (disjointed and darkly funny, *Suspiria* is a gothic comedy). Douglas's work is cinematic precisely insofar as it is post-cinematic; in other words, it is part of the migration of cinematic tropes into the wider culture at the precise moment when the cinema as a system of production and distribution, as exemplified by the Hollywood studio system, had all but collapsed. This collapse did not mean the end of film as a cultural force; rather, film was now everywhere: on TV, on video (and later DVD), and in magazines and countless books.

One form of the cinema's post-cinematic afterlife was the film still, which came to play a prominent role in art in the late 1970s. Here one can think, obviously, of Cindy Sherman's *Untitled Film Stills* but also of the image of the falling man that Robert Longo culled from a still of Fassbinder's *The American Soldier*, and of Jeff Wall's "cinematic" light-box photographs.[11] Film stills seemed to distill the essence of the filmic, as Barthes put it, suggesting potential narratives beyond stock formulas, lifting moments of pure

11 Wall distinguishes between his "cinematographic photographs," which involve some degree of staging or of alterations to the location, and his "documentary photographs."

cinema from humdrum plots. Although the still has of course accompanied the cinema almost from the beginning, it unfolded its potential in a period when, on the one hand, *Cahiers du cinéma*-style cinephile culture experienced its Indian Summer, while on the other hand the arrival of the Spielberg-style blockbuster signaled a fundamental change in the cultural climate, in which the production and distribution of "difficult" films would itself become ever more difficult.[12]

The photographs accompanying Stan Douglas works such as *Nu·tka·*, *Der Sandmann*, or *Le Détroit* are not film stills, though they perform some of their functions. They show locations or sites associated with the films, but they do not show characters or actions, nor do they mimic the film's style. While film stills traditionally do differ from actual film frames—they are shot on the set by a photographer—they hardly exacerbate the differences to the extent that Douglas's photos do. Still, Douglas's photos are clearly offshoots of the film projects; they cannot lay claim to being "purely photographic." Rather, they are part of the films' intermedial unfolding. With *Abbott & Cordova,* Douglas does create a more explicitly "cinematic" photograph, a still motion picture. One way of analyzing this media hybrid is in terms of the dialectic of *image* and *picture.*

De- and rematerialization

In contrast to "picture," the term "image" can be used for mental or dream images. "Picture" has strong connotations of a concrete, physical artifact, though the "moving pictures" of the cinema have something of the quality of ephemeral dream images. In the first version of his "Pictures" essay, which accompanied the eponymous exhibition, Douglas Crimp noted that "[to] an ever greater extent our experience is governed by pictures, pictures in newspapers and magazines, on television and in the cinema."[13] Crimp then focused on pictures as more or less concrete entities in various media. In the second version of the text, he would pit his approach against Michael Fried's longing for transcendental "presentness" in his essay *Art and Objecthood*, creating an anti-Friedian genealogy (going back to Mallarmé) of work that does "not seek the transcendence of the material conditions of the signs through which meaning is generated."[14] However, as Crimp noted, the "paradox of the picture" is that it is "simultaneously present and remote"; the first version of his essay in particular examined how some artists create

12 For a trenchant characterization of this development and some of its consequences, see Hito Steyerl, "In Defense of the Poor Image," in *e-flux journal* 10 (November 2009), http://www.e-flux.com/journal/view/94

13 Douglas Crimp, "Pictures," in *Pictures* (New York: Artists Space, 1977), 3.

14 Douglas Crimp, "Pictures" (second version from 1979), in *Art After Modernism: Rethinking Representation,* ed. Brian Wallis (New York/Boston: New Museum of Contemporary Art/David R. Godine, 1984), 186.

LA PLUS GRANDE PHOTOGRAPHIE DE LA GUERRE. — Prise de la crête de Vimy par les Canadiens.
AGRANDISSEMENT DE « N. 1ᵉʳᵉ », SUR 3 M. 35, FIGURANT A L'EXPOSITION DES PHOTOGRAPHIES DE GUERRE DU GOUVERNEMENT CANADIEN

"La Plus Grande Photographie de la guerre." *L'Illustration,* December 19, 1917

images that evoke dreams or memories, noting the case of a work by Troy Brauntuch that it is "the materialization of reverie."[15]

One can read both versions of Crimp's essay against the background of developments in modern media technology. With photography, images seemed to aspire to the status of reverie—materialized in prints, to be sure, but never firmly tied to a single materialization. An intriguing text from the nineteenth century in which photography was presented as an agent of dematerialization was written in 1859 by Oliver Wendell Holmes, who stated: "Form is henceforth divorced from matter. In fact, matter as a visible object is of no great use any longer. Give us a few negatives of a thing worth seeing, taken from different points of view, and that is all we want of it. Pull it down or burn it up, if you please … Matter in large masses must always be fixed and dear; form is cheap and transportable. We have got the fruit of creation now, and need not trouble ourselves with the core."[16] Photography, then, seemed to present form without matter, a form that for Holmes is equal to content—pure visual information that can be contained in "a few negatives." These negatives function as virtual or potential images waiting to be actualized in prints, in pictures.

Photography was thus positioned as the anti-monumental medium par excellence, replacing heavy volume with infra-thin images. Holmes, writing in an age of long exposures, still considered the task of "mobile" photography to be the registration of stationary bodies. The emergence of the snapshot has obviously changed this—and indeed an early monumental photograph (the size of a massive history painting), a scene of a Canadian unit in combat exhibited in 1917 in Paris, extolled this characteristic of the medium (see above).[17] Usually, Stan Douglas photographs refrain from showing

15 Crimp, "Pictures" (1979), 10, 14.
16 Oliver Wendell Holmes, "The Stereoscope and the Stereograph," in *The Atlantic Monthly* 3, no. 20 (June 1859), 738–48, http://www.theatlantic.com/past/docs/issues/1859jun/holmes.htm
17 This monumental photograph, which was assembled from five partial prints of the "*splendide instantané*" taken on April 9, 1917, measured 3.35 x 6.10 m. See *L'Illustration,* December 19, 1917.

Vimy, "snap shot."
Canadian War Museum,
George Metcalf
Archival Collection,
CWM 19920085-915

human actions, focusing instead on the landscape and architecture of sites related to his film projects, but in the case of *Abbott & Cordova,* a staged "cinematic" scene takes on photographic form. Rather than replacing a building, it transforms a building by infiltrating it with a quasi-filmic scene of another location that had been reconstructed in the form of a movie-type set—a Potemkin village, a hollowed-out copy of the street corner.

In the meantime, of course, technology has made yet another leap into the dematerialized. Douglas's photo is an image without an original; it is a digital composite of numerous shots. Writing about digital culture, Boris Groys has emphasized that digital images need to be performed in order to be seen. "Digital images have the propensity to generate, to multiply, and to distribute themselves almost anonymously through the open fields of contemporary communication. The origin of these messages is difficult, or even impossible, to locate, much like the origin of divine, religious messages. At the same time, digitalization seems to guarantee a literal reproduction of a text or an image more effectively than any other known technique. Naturally, it is not so much the digital image itself as the image file, the digital data which remains identical through the process of its reproduction and distribution. However, the image file is not an image—the image file is invisible. The digital image is an effect of the visualization of the invisible image file, of the invisible digital data. [...] Digital data should be visualized, should become an image that can be seen. Here we have a situation wherein the perennial spirit/matter dichotomy is reinterpreted as a dichotomy between digital file and its visualization, or 'immaterial information' and 'material' image, including visible text."[18]

What I have termed the dialectic of image and picture prefigures some of the aspects of Groys's dichotomy, which can be seen as its digital incarnation. With analog photography and film, we are dealing with images that are *potential pictures* until they are realized by being printed (photography) or screened (film). In the latter case, that of moving pictures, they always retain a somewhat dream-like and unreal character. Film stills seem to "fix" this; here the film truly becomes a picture, yet this picture also teems with potential films, generating mental images. With Stan Douglas's photographs, it can be an interesting experience to see them before having seen the film; their photographic qualities assert themselves, but on the other hand, one cannot

18 Boris Groys, "Religion in the Age of Digital Reproduction," in *e-flux journal* 4 (March 2009), http://www.e-flux.com/journal/view/49

help speculating and fantasizing about the film to which they are related, turning them into projection screens for one's expectations. In the case of *Abbott & Cordova*, the situation is different: the film *is* the photo.

The image is a narrative, quasi-cinematic photo showing actors or extras in a number of groups or constellations, but perhaps the main performative dimension is not to be located here, but in Douglas's assemblage, creating a digital image waiting to become picture. *Abbott & Cordova* exists in the form of a "regular" gallery print, a part of Douglas's photo series *Crowds & Riots*, but this version is somewhat eclipsed by the one installed in the atrium of the Woodward's building. Here, the image file is "performed" in a very specific and very public setting. Passersby participate in its collective staging.

Open to the gaze from both sides, its visibility depending on the light at any given moment, the work functions as a large slide that has been integrated with the architecture. Here, photography does not replace matter but infiltrates it, with a result that may be *cinematic* not primarily because of the set or the elaborate shoot, but because it exists in a montage with the flux of passersby, of potential spectators who cannot help becoming performers themselves. The result is a perpetually shifting constellation. Refusing to blend its component parts into a romantic symbol, into an organic whole, the work also invites the viewer-performer to engage in an additional act: to study and reflect on Vancouver's urban and social history.

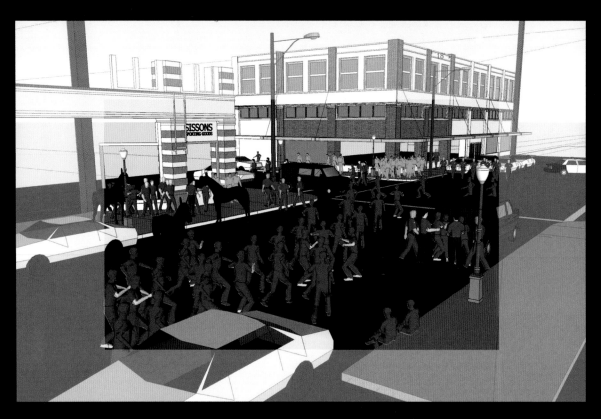

Stan Douglas, 3-D model of shoot for
Abbott & Cordova, 2008

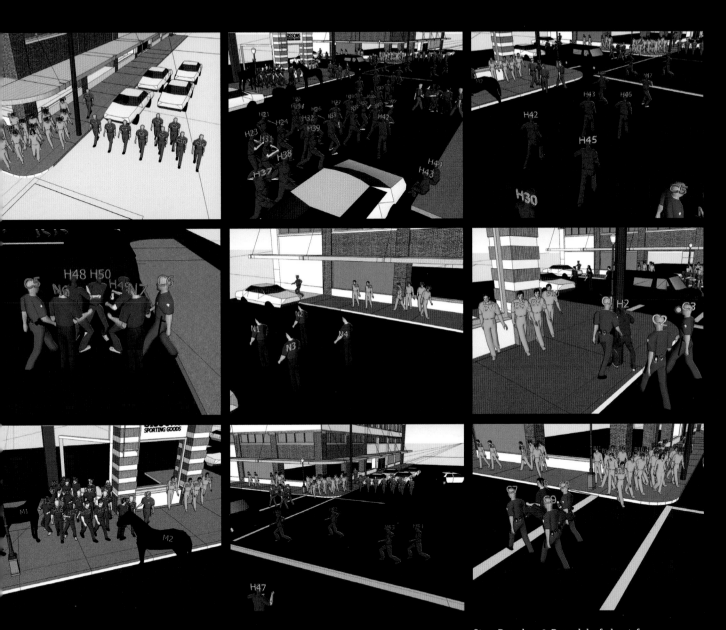

Stan Douglas, 3-D model of shoot for
Abbott & Cordova, 2008

THE DERELICT, THE DESERVING POOR, AND THE *LUMPEN*
A History of the Politics of Representation in the Downtown Eastside

Jesse Proudfoot

Immediately to the left of Stan Douglas's *Abbott & Cordova, 7 August 1971*, a series of posters featuring portraits and quotations proposes an interpretation of the Woodward's site and its historical significance. Adorning the entrance to one of the chain stores, they depict local residents and their answers to questions such as, "What do you think of the changes going on in the area?" and "What do you think about the Woodward's development?" Considering that the piece was created by the developers, it is unsurprising that it offers a sunny interpretation. The carefully chosen faces of marginalized Downtown Eastside residents, new middle-class arrivals, and community leaders all speak of the positive impacts of the new development and the ongoing gentrification of the neighbourhood. Couched in the language of "social mix," their quotations extol the virtues of "diversity," misleadingly implying that the Downtown Eastside—one of the most diverse neighbourhoods in the city—somehow lacked diversity in the past. The quotes trumpet the social housing component of Woodward's, even though the number of housing units is a fraction of what community groups argued was necessary. And they make fallacious claims that the new businesses are employing Downtown Eastside residents and helping them to "get off the streets"— as if the problem of poverty in the Downtown Eastside was the result of too few minimum-wage jobs.

Writing on Douglas's piece in *The Walrus*, Leigh Kamping-Carder[1] remarks that real-estate developers often forget that neighbourhoods like the Downtown Eastside are palimpsests—spaces continuously written over by different social groups throughout their history. Pace Kamping-Carder, what texts like those described in the previous paragraph suggest is that developers are in fact acutely aware of the histories of the places they seek to remake, at least insofar as it helps them sell condominiums. The quotations attributed to this all-too-perfect collection of faces are uncanny precisely because they seem to address every facet of the public discourse around Woodward's, seeking to reassure new property-owners that not only is their investment secure but that their very presence is beneficial to the community. The ideological centre of the text is found in a quote from "Ali," who, in giving his thoughts on how the neighbourhood will change, jokes, "[I]n five years, I won't be able to afford a coffee here." To the newly-arrived middle class being hailed by this discourse, the message is clear: *Don't sweat the bad reputation; this place is going to be worth a fortune.*

It is in this politically contested space that we encounter Stan Douglas's *Abbott & Cordova*, a depiction of a 1971 riot in which police attacked a group of hippies protesting marijuana prohibition. It is a somewhat frivolous protest compared to the

1 Leigh Kamping-Carder, "At the Gastown Riot," in *The Walrus* (July-August, 2009); http://www.walrusmagazine.com/articles/2009.07-profile-at-the-gastown-riot-stan-douglas-walrus-vancouver-art/.

Woodward's development posters, July 22, 2011. (Photo: Colleen Heslin)

political struggles more commonly associated with the neighbourhood: the labour strife of the 1930s, the fight against urban renewal and demolition in the 1960s, or the struggles against gentrification (including the occupation of the Woodward's building itself) in 2002. Nevertheless, in this minor event located at the periphery of the protest movements of the 1960s, we encounter a powerful representation of the naked violence of the state brought to bear on a group of people.

What can be said about the politics of this image? What function does it perform here in the historically overdetermined space of the Woodward's building? On one level, *Abbott & Cordova* is a representation of a riot and can be read as a powerful indictment of state repression and police brutality, and as a defence of civil liberties during a time of social upheaval. In so far as it dredges up an uncomfortable past, the image offers an important corrective to sanitized histories of the neighbourhood that efface the traces of conflict from the palimpsest of the Downtown Eastside. We can also discern parallels between that historical period and our own, reading the piece as a reminder that such political struggles and violent repression continue, even if the issues and actors differ.

Conversely, we can read the piece looking not for similarities but differences, and call attention to what might be effaced in this representation. In this reading, we look at the riot and ask: Whose riot? Which community is being represented? Hippies are not the first group that Vancouverites associate with the Downtown Eastside of the 1970s. They were, after all, only recent arrivals to the neighbourhood. The more iconic figures of the Downtown Eastside were the working-class men living in the neighbourhood's residential hotels—those men who look on like detached spectators from the peripheries of Douglas's mural. We are therefore entitled to ask about the important class differences between the middle-class protest depicted in *Abbott & Cordova* and the traditionally working-class politics of the Downtown Eastside. Indeed,

why is it that in Woodward's, at the very site of the neighbourhood's most contentious battles over gentrification, we find the depiction of a riot concerned not with the politics of redistribution but the politics of (marijuana) consumption? Could we argue that *Abbott & Cordova* functions as a sort of gentrification of the political history of the Downtown Eastside? Could we even suggest that it somehow apologizes for the gentrification of Woodward's by providing an image of middle-class protest for the gentrifiers to identify with, thereby legitimizing their presence in the neighbourhood as the rightful inheritors of the legacy of the 1960s protest movement?[2]

This line of questioning likely goes too far, for it is clear that Douglas intends quite the opposite with the piece. It's clear that he intends this image of a notorious riot to facilitate a discussion about the contested history of the neighbourhood. Nevertheless, it is precisely because such a conversation is necessary that it is essential to pay attention to how class and class struggle are articulated in representations of the Downtown Eastside—especially when real estate developers are actively engaged in writing their own histories of the neighbourhood with the goal of making it safe for property speculation rather than political discussion.[3]

In the historical analysis that follows, I take up these issues of class, class struggle, and the politics of representation. Following Douglas's remark that *Abbott & Cordova* concerns a moment of transition for the neighbourhood, I discuss a series of interrelated transitions that have had profound effects on the Downtown Eastside. Such transitions have had equally powerful effects for political efforts to improve the lives of the people who live here. The central transition I am concerned with is representational: it is the transformation of public discourse about the Downtown Eastside primarily as a result of political struggle from a variety of groups within the community. Specifically, I focus on the articulation of a discourse of "working-class community" by the Downtown Eastside Residents Association (DERA) in the 1970s and 1980s as a reaction to the earlier language of "skid row" and the subsequent challenges that discourse has faced since then. This latter transition is tied to an

2 I argue that it is precisely this sort of middle-class, counter-cultural identification that condo marketer Bob Rennie was aiming at when he enjoined prospective Woodward's buyers to "be bold, or move to suburbia." Rennie Marketing Systems, *Woodward's District*. http://www.woodwardsdistrict.com, 2006. The slogan has since been removed from the website; a supplementary reference to the slogan can be found in: Tim Carlson, "Condofest," in *Vancouver Review* no. 10, Summer 2006; http://www.vancouverreview.com/past_articles/condofest.htm.
3 The necessity of such analyses is made clear by another representation offered by the developers of Woodward's. In a didactic panel (located on the Hastings side of the building) discussing the history of Woodward's, they appear to argue that the Woodward's development represents the *successful* culmination of the 2002 "Woodsquat" occupation of the Woodward's building by activists and homeless people. Given that many activists view Woodward's as the complete *failure* of their struggle against gentrification, this argument should be read as an attempt at ideological recuperation whereby a history of opposition is co-opted by the victors. With respect to my claim that the developers are not interested in fostering political discussion, it is also worth noting that the Woodward's building has repeatedly refused Simon Fraser University students—who attend school in the building—the right to hold protests on campus.

important demographic shift in the neighbourhood: the diminishing numbers of retired resource workers who once populated the neighbourhood's hotels. As a result of this shift, there have been changes in the political actors who have been able to successfully articulate a narrative of the neighbourhood. In this case I chart the shift in power from DERA in the 1980s to the Portland Hotel Society (PHS) in the present day. Entwined in these transformations are a host of others: transitions from industrial to post-industrial, from alcohol to heroin and then to crack, and from the "respectable" working-class to the "undeserving" *lumpenproletariat*.

The area now known as the Downtown Eastside was Vancouver's original town site. Comprised of a number of distinctive sub-areas, including Gastown, Chinatown, and Strathcona, it extends as far east as Clark Drive and abuts the central business district in the west.[4] The "Granville town site," as it was named by royal surveyors in 1870, was built on a beach called *Luk'luk'i*, a seasonal food-gathering settlement of the Squamish, Tsleil-Waututh, and Musqueam First Nations.[5] Chosen because of its proximity to the nearby Stamp's Mill, the town site was organized around resource extraction and processing, activities which grew and persisted well into the twentieth century. An industrial waterfront emerged in the area comprised of canneries, warehouses, grain elevators, dockyards, and rail yards alongside a lodging-house district centred on Carrall and Cordova streets. Here, the loggers, miners, and migrant labourers of the hinterland found temporary accommodation in the numerous rooming hotels after returning from months of isolation in remote work camps. Beer parlours, cafés, and other businesses catering to these mobile, single men abounded in the dense few blocks around Maple Tree Square, which soon became known as the loggers' district.[6]

As the city grew, affluent Vancouverites moved farther west, away from the sights and pungent smells of the industrial waterfront, making the Downtown Eastside the centre of the city's working class. With its concentration of hard-working and hard-living men, the neighbourhood quickly acquired a reputation for being a rough part of town.[7] Widespread unemployment during the Great Depression did nothing to help this situation, and the neighbourhood also became known for confrontation after a series of violent clashes between police and unemployed men: striking longshoremen

4 The boundaries of the Downtown Eastside have been the subject of a great deal of politicized debate, with community groups fighting against government and real estate developers, often for the simple recognition of the neighbourhood's existence. When I speak of the Downtown Eastside, I employ the definition advanced by neighbourhood groups (and eventually adopted by the city), but by and large limit my discussion to the lodging-house areas of Gastown, Oppenheimer, and the Hastings corridor.

5 City of Vancouver, "Carrall Street Greenway: Natural History," http://vancouver.ca/engsvcs/streets/greenways/city/carrall/history_natural.htm.

6 Rolf Knight, *Along the No. 20 Line: Reminiscences of the Vancouver Waterfront* (Vancouver: New Star Books, 1980), 29–30.

7 Jeff Sommers, "Men at the Margin: Masculinity and Space in Downtown Vancouver, 1950–1986," in *Urban Geography* 19 no. 4 (1998), 292-293.

clashed with police at Ballantyne Pier in 1935, and, in a series of conflicts, groups of unemployed men occupied numerous public buildings including the Carnegie Library, the Hudson's Bay Company, the Post Office, and Art Gallery at different times throughout the 1930s.[8]

While the war-time recovery of Vancouver's economy cooled tempers somewhat, the economic recovery did not include the Downtown Eastside. Expansion of the highway system changed the dynamics of transportation such that waterfront industries could now relocate to cheaper land in the suburbs. The closure of the Union Steamship docks at the foot of Carrall Street and nearby North Shore ferries, as well as the end of streetcar transport along Cordova and Hastings around this time, also contributed to a massive decrease in pedestrian traffic through the neighbourhood.[9]

The neighbourhood—with its cheap hotels and beer parlours filled with working-class men—had long been associated with vices such as drinking, prostitution, and the racialized anxieties surrounding the gambling and opium "dens" of Chinatown. In the 1950s, with the neighbourhood in profound economic decline, these moral anxieties coalesced into a language of "skid row."[10] Residents of the Downtown Eastside were now characterized as deviants, derelicts, and criminals in local media, and stories of alcoholism, drug use, and violence filled the newspapers. The neighbourhood itself became a "square mile of vice"[11] whose "canned-heaters, drug addicts" and "streetwalkers"[12] were described in lurid detail by the press.

The rooming houses and residential hotels in these years housed a large number of retired resource workers.[13] The men who had once stayed in the neighbourhood during the off-season or between jobs were now settled there permanently, making up a large and stable percentage of the community. By the late 1950s and early 1960s, new social groups began to arrive, including transient men, First Nations people, and younger substance abusers.[14] Heroin also appeared around this time and a nascent street-drug scene emerged on the corner of Main and Hastings streets. The three decades following World War II thus saw a continued deterioration in the neighbourhood. A number of factors—including the end of the streetcar service that brought pedestrians to the

8 Schlomo Hassan and David Ley, "The Downtown Eastside: 100 Years of Struggle,"in *Neighbourhood Organizations and the Welfare State*, Hassan and Ley, eds. (Toronto: University of Toronto Press, 1994), 174 .

9 Larry Campbell, Neil Boyd, and Lori Culbert, *A Thousand Dreams: Vancouver's Downtown Eastside and the Fight for its Future* (Vancouver: Greystone Books, 2009), 12; City of Vancouver, "Carrall Street Greenway: Evolution of the Communities," http://vancouver.ca/engsvcs/streets/greenways/city/carrall/history_evol.htm

10 Sommers, "Men at the Margin," 296.

11 W.L. MacTavish, "Poverty Row in Vancouver is Square Mile of Vice," *Windsor Daily Star*, (July 10, 1947), 1, http://news.google.com/newspapers?id=nxw_AAAAIBAJ&sjid=hE8MAAAAIBAJ&pg=3895%2C1223589.

12 "Vancouver Police Search 'Skid Row,'" *Montreal Gazette* (July 17, 1951), 13, http://news.google.com/newspapers?id=94QtA AAAIBAJ&sjid=lJkFAAAAIBAJ&dq=skid%20row%20vancouver&pg=7121%2C2152554.

13 Sommers, "Men at the Margin," 296.

14 Hassan and Ley, "The Downtown Eastside," 175.

neighbourhood, increasing suburbanization (affecting traditional downtown retailers like Woodward's), and the arrival of new groups of very poor people in the Downtown Eastside—all contributed to the production of an economically depressed neighbourhood with increasingly pressing social problems.

These problems were defined in terms of "blight" and "urban decay" by city planners and gave rise to proposals for "urban renewal" to change the neighbourhood. Consistent with the planning ideology of the 1960s, such proposals often took the form of large-scale demolition and high-rise construction. Project 200, put forward in 1965 by a coalition of business and government forces, proposed fourteen new office towers and a massive freeway expansion that would demolish most of Gastown and Chinatown.[15] The proposal sparked opposition from a wide variety of groups including Strathcona property owners, Downtown Eastside social workers, and heritage preservationists, who eventually succeeded in preventing the plan from being realized.[16] So, while social problems were deepening at the time of the 1971 riot depicted in Douglas's photograph, the Downtown Eastside was still a relatively stable working-class community entering the decade on a wave of successful community organizing and resistance.

The Downtown Eastside Residents Association was officially incorporated in 1973. Modelled as a sort of trade-union for low-income people, it was the product of a unique period in the history of the Canadian welfare state, when governments attempted to assimilate oppositional movements, such as those that had opposed Project 200, by granting them official status and providing them with funds.[17] Initially headed by Bruce Eriksen, a Downtown Eastsider who had spent his working life in resource and industrial jobs, DERA quickly proved to be too politically confrontational to benefit from this largesse, of the state. Only three years later, when their funding was rejected by city council in 1976, DERA had already grown to 2,000 members and had embarrassed the municipal government on many occasions through rallies, pickets, and raucous appearances at council.[18] The object of these actions was consistent: to improve the living conditions of their membership, the retired resource workers living in the neighbourhood's residential hotels. DERA framed their demands using the discourse of equality, arguing for equal enforcement of the law in the Downtown Eastside as was expected in other parts of the city. An important aspect of this demand

15 Jeff Sommers and Nicholas Blomley, "The Worst Block in Vancouver," in *Stan Douglas: Every Building on 100 West Hastings*, ed. Reid Shier (Vancouver: Arsenal Pulp Press and Contemporary Art Gallery, 2002), 35; Heather Smith, "Planning, Policy and Polarisation in Vancouver's Downtown Eastside," *Tijdschrift voor Economiche en Sociale Geografie* 94, no. 4 (2003), 497.

16 One important strategy in the fight against Project 200 was the 1971 heritage designation of Gastown. On this point, see Smith, "Planning, Policy and Polarisation" 501.

17 Sommers, "Men at the Margin," 305.

18 Hassan and Ley, "The Downtown Eastside," 181, 186.

was the enforcement of building codes and fire regulations, bylaws that were frequently ignored in the dilapidated hotels of the Downtown Eastside, often with disastrous consequences for those who lived in them. In 1973 alone, there were 107 hotel fires in the neighbourhood, which claimed the lives of ten people.[19] DERA's membership and influence continued to grow throughout the 1980s, with the organization claiming 4,500 members in 1989 and two of its executive, Bruce Eriksen and Libby Davies, making the leap to formal politics when they were elected to city council early in the decade.

At the same time as DERA was making real progress in organizing residents and lobbying on their behalf, economic and social decline continued in the neighbourhood. The deinstitutionalization of significant numbers of mentally-ill patients from Riverview hospital, often without adequate support systems, led to many of these people moving to the Downtown Eastside in search of affordable accommodations. The neighbourhood's heroin trade also grew explosively throughout the 1970s, and the 1980s saw the arrival of crack cocaine, which only compounded the neighbourhood's problems with addiction.

Gentrification in other parts of the city, such as Kitsilano, Fairview, and the West End, which saw the conversion of single room occupancy (SRO) accommodations to middle-class apartments, put additional pressure on the neighbourhood to absorb the city's low-income singles.[20] These problems came to a head in the lead-up to Vancouver's hosting of the World Exposition in 1986 (Expo '86). The Expo grounds' proximity to the Downtown Eastside raised concerns that a high-profile mega-event would have disastrous effects for the neighbourhood through upwards pressure on rents and increased real-estate speculation. DERA raised the alarm early on the fact that Downtown Eastside hotel owners intended to convert their properties to tourist accommodation and evict long-term tenants, many of whom had lived there for decades. Pressure on city council to enact rent freezes and moratoriums on conversions fell on deaf ears, and Expo resulted in an estimated 500 to 950 tenants being evicted from their homes in the lead-up to the event.[21] DERA was later successful, in part because of this tragedy, in pushing for legislation that extended tenant rights to the men of the rooming hotels in 1989. Nevertheless, the Expo evictions had a destabilizing effect on an already changing community.[22]

While much of DERA's efforts were directed at material struggles around

19 Ibid, 192.
20 David Ley, *The New Middle Class and the Remaking of the Central City* (Oxford: Oxford University Press, 1996), 67.
21 Kris Olds, "Urban Mega-Events, Evictions and Housing Rights: The Canadian Case," *Current Issues in Tourism* 1 no. 1 (1998), 13.
22 Smith, "Planning, Policy and Polarisation ...," 499.

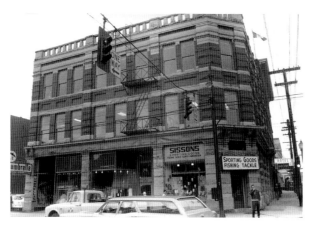

Cordova Street, 1968. City of Vancouver Archives, CVA1095-201E3_F8S347F17 (1968)

tenants' rights and living standards, in important ways they were also concerned with issues of representation. The principal target was the discourse of "skid row" that had come to define the neighbourhood since the 1950s. Skid row described a space filled with transients and derelicts, a neighbourhood in which the washed-up inevitably found themselves. Against this popular image, which was endlessly repeated in the press and civic discourse, DERA advanced a counter narrative of working-class community, drawing on the collective history of the retired men who made up their membership. They emphasized the residential stability of the neighbourhood—the second highest in the city—and the deep connection many felt to the community.[23] Jeff Sommers discusses this process in terms of the production of a new dominant figure in the neighbourhood: where once the "derelict" had represented skid row, now stood the figure of the "retired resource worker."[24] By the mid-1980s, when the Expo evictions occurred, the success of DERA's rearticulation of the neighbourhood's inhabitants was made evident by the appropriation of this figure by journalists: "[T]hey are blasters, loggers, union workers, old soldiers, fathers, mothers, grandparents ... They are poor now, but before their bodies grew old and began to break they were working to help build this country."[25] The most striking example of DERA's successes at the level of representation comes in the name of the neighbourhood itself: whereas the area was once referred to as "Skid Road,"[26] after a decade of discursive work, DERA had succeeded in renaming the neighbourhood as the Downtown Eastside, even receiving a citation to that effect from the mayor.[27]

23 Hassan and Ley, "The Downtown Eastside" 190, 178.
24 Sommers, "Men at the Margin," 300.
25 Mark Hume, 1986, cited in Sommers, "Men at the Margin," 299. See also the two most important texts in the production of this narrative: Rolf Knight's *Along the No. 20 line* (1980), and Jo-Ann Canning-Dew's *Hastings and Main: Stories from an Inner City Neighbourhood* (1987), the latter a product of research by Carnegie Centre, itself a product of DERA's lobbying (Sommers, 301).
26 "Skid Road" is a Vancouver variant of the more common term "skid row."

This transformation of the neighbourhood at the level of representation is one of DERA's greatest legacies. The replacement of the figure of the derelict with that of the retired resource worker has been immensely important to the neighbourhood in its struggles for recognition and equal treatment under the law.[28] It should be apparent, however, that such an ideological re-articulation, while radical in its own way, is not without its problems. Principal among these is the reification of a very bourgeois binary between the deserving and undeserving poor. In many ways, DERA succeeded in winning support for its agenda in the larger political field only by mimicking the vocabulary and conceptual framework of Vancouver's elite. In other words, DERA argued that Vancouverites were wrong to stigmatize the retired workers of the Downtown Eastside as derelicts on *empirical* grounds—because they weren't really derelicts—rather than undermining the ideological framework itself and arguing that, derelicts or not, Downtown Eastsiders deserved equal treatment and recognition.[29]

Jeff Sommers, drawing on Iris Marion-Young, argues that "the deployment of a rhetoric of community ... also produced a series of exclusions." Counterpoised to the retired resource worker were the "criminals, drug addicts, and alcoholics" who preyed on the worthy poor and degraded the neighbourhood.[30] The representation that DERA advanced about the neighbourhood and its inhabitants, while successful in enfranchising many, was nevertheless a representation that did not laud everyone: "[I]t was a representation of only *some* bodies" and served to suppress "the identities of the many others who used that space."[31]

This distinction might be no more than academic if it actually were the case that the neighbourhood was entirely composed of the type of men hailed by this discourse.[32] This was never the case, of course, and more significantly, from the late 1980s onwards, the picture in the Downtown Eastside has changed even more. The numbers of retired resource workers in the neighbourhood has gradually declined due

27 Hassan, Schlomo and David Ley, "The Downtown Eastside: 100 Years of Struggle," 190.

28 There were, of course, more concrete achievements as well, such as the remarkable amount of social housing DERA succeeded in having built in the neighbourhood.

29 Some may argue that DERA's language was not always exclusionary and did in fact "hail" the very groups I am claiming they positioned as "outsiders." DERA produced a great deal of texts over its tenure, some of which may contradict my claim. Doubtlessly, many of the struggles they undertook (for example, in fighting for enforcement of fire codes in hotels) certainly benefited everyone in the Downtown Eastside. Nevertheless, there are numerous examples that speak to the distinction I am identifying and, in any case, my argument does not depend on whether the "blame" rests on DERA for the reification of the deserving/undeserving poor binary: what is important is that *this* was the language that was successful in changing public opinion and was repeated in newspapers and civic discourse. This issue is critical because this discourse is what comes under threat when the figure of the now-respectable retired resource worker is no longer dominant in the neighbourhood.

30 Sommers, "Men at the Margin," 302; see also: Iris Marion-Young, *Justice and the Politics of Difference* (Princeton: Princeton University Press, 1990), chapter 8.

31 Sommers, "Men at the Margin," 305.

32 By the end of the 1980s, DERA's membership also included a significant minority of Chinese-Canadian women. While this speaks well to the diversity of residents the group was able to attract, it should still be clear that other groups were excluded.

to aging and the legacy of the Expo evictions.[33] As these men have passed on, they have not been replaced by another generation of resource workers, because those jobs have, by and large, left the city or disappeared altogether. Indeed, since the late 1980s a new, younger cohort has come to dominate the neighbourhood's SRO hotels: heroin and cocaine users, women involved in the sex trade, First Nations people, the mentally ill: in short, people *even more marginalized* than the generation that preceded them and people who are exemplary of those *not* included in the discourse of the noble poor.[34] According to Jeff Sommers, this transition has meant that the "iconic representation of the aging resource-industry worker has been increasingly hard to reconcile with reality."[35]

This "younger, meaner, rougher crowd,"[36] as the city's planning department put it, grew substantially over the 1990s and 2000s, changing the character of the neighbourhood from one recognized by the generation of loggers as a community, to a neighbourhood that began to look more and more like a "U.S.-style inner city ghetto."[37] Storefront vacancies along Hastings increased dramatically, leaving the neighbourhood looking derelict and abandoned.[38] The 1990s saw an explosion in HIV transmission among the IV drug-using population that was the highest in the developed world, prompting the Vancouver-Richmond Health Board to declare the city's first "public health emergency"[39] in 1997. Deaths attributed to illegal drugs nearly doubled over the 1990s and overdose deaths reached 300 annually.[40] Homelessness increased as Vancouver's real estate market became the most expensive in the country, giving an even more visible character to poverty in the neighbourhood: drugs or alcohol once consumed in hotel rooms were now increasingly consumed on the street, in full view of drivers passing through.

These transitions are the result of processes I have identified above: the growth of the drug trade, deinstitutionalization and erosion of support for mental patients, the widespread loss of affordable housing in other parts of the city, as well as macro-

33 There is still a high percentage of seniors (i.e., over sixty-five) in the Downtown Eastside (twenty-two percent compared to thirteen percent in the city overall in 2005–06 (*2005/06 Downtown Eastside Community Monitoring Report,* 8), so demographics fail to capture this transition. It can be inferred, however, from two factors: the disappearance of resource sector jobs from the neighbourhood and from the ages of this generation: if DERA claimed in 1987 that the average Downtown Eastsider was a former resource worker aged fifty-five, those men would be nearing eighty years of age in 2011 in a neighbourhood where men's life expectancy is sixty-six.

34 Smith, "Planning, Policy, and Polarisation," 499; Sommers, "Men at the Margin," 305.

35 Sommers, "Men at the Margin," 305.

36 City of Vancouver, *Downtown Eastside: Building a Common Future, Report #1 for Council Consideration* (Vancouver: Planning Department of Vancouver, 1998) 2.

37 G. Middleton, "Skid Row Shooter Sought," in the *Province* (September 18, 1996, A11), cited in Sommers, 305.

38 Between 1986 and 2001 storefront vacancies increased from thirteen to forty-three percent. CCAP "Thirty Years of Retail Activity on Hastings Street," cited in Smith, "Planning, Policy and Polarisation ..." 500.

39 Larry Campbell, Neil Boyd, and Lori Culbert, *A Thousand Dreams: Vancouver's Downtown Eastside and the Fight for its Future* (Vancouver: Greystone Books, 2009), 111.

40 Millar, John S., *HIV, Hepatitis, and Injection Drug Use: Pay Now or Pay Later?* (Victoria, BC: Office Of the Provincial Health Officer, BC Ministry of Health), 1998, i.

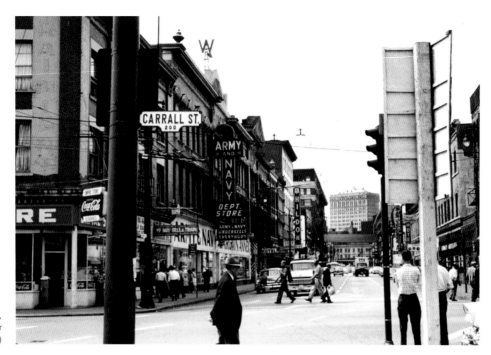

Carrall and Cordova streets, 1960s. City of Vancouver Archives, CVA780_768 (196_)

economic factors such as the neoliberal retrenchment of the welfare state. Taken together, they amount to what I call a process of *lumpenization* in the Downtown Eastside: a deepening of poverty and breakdown of the earlier community.

Marx and Engels use the term *lumpenproletariat* to refer to the social class below the traditional proletariat. They refer to this unemployed, property-less group as "vagabonds, discharged soldiers, discharged convicts ... swindlers, charlatans, pickpockets ... rag-pickers, beggars."[41] In the contemporary Downtown Eastside, I use the term *lumpen* to refer to those radically excluded from traditional working-class citizenship: drug users, panhandlers, prostitutes, and petty drug dealers; in short, the same groups stigmatized with the designation of the "undeserving poor." It is the growth of this population since the 1980s and their concentration in the Downtown Eastside that has produced the transition I refer to here as *lumpenization*.

Progressive scholarship and political activism have had a long and troubled relationship to the *lumpen* that extends as far back as Marx and Engels' first formulation of the category. In the *Manifesto*, they refer to the *lumpen* as "the 'dangerous class,' the social scum, that passively rotting mass thrown off by the lowest layers of old society. [The lumpen] may, here and there, be swept into the movement by a proletarian revolution; its condition of life, however, prepares it far more for the part of a bribed tool of reactionary intrigue."[42] The *lumpen*, according to Marx and Engels, live a "degrading, destructive mode of life";[43] they lack any sense of class consciousness and exist parasitically, preying on the working class or acting as pawns of the bourgeois in putting down proletarian revolution. While rarely expressed with the vehemence

41 Karl Marx, trans. D.D.R., *The Eighteenth Brumaire of Louis Bonaparte* (New York: Mondial, 2005), 46.
42 Karl Marx and Friedrich Engels, trans. Samuel Moore, *The Communist Manifesto* (London: Penguin Books, 1967), 92.
43 Robert Bussard, "The 'Dangerous Class' of Marx and Engels: The Rise of the Idea of the *Lumpenproletariat*," in *History of European Ideas* 8, no. 6 (1987), 683.

we encounter here, this hostile attitude toward the *lumpen* parallels some of the exclusions one occasionally encounters in contemporary progressive movements. And while DERA was not concerned that the *lumpen* of the Downtown Eastside would sabotage their efforts by assisting Vancouver's elites, they were nevertheless portrayed as "outsiders," preying on the noble working class whose image DERA had worked to rehabilitate.[44]

Stan Douglas, *Every Building on 100 West Hastings,* 2001. Digital chromogenic print. Image dimensions: 26 x 172 in

The idea of the *lumpen* as a group lacking class consciousness also has parallels in the Downtown Eastside. While DERA was able to consolidate a class identity for its members drawing on a shared history and genuine attachment to the community, this was not necessarily the case for *lumpen* groups. Indeed, I would argue that many of the *lumpen* of the Downtown Eastside do not have a strong sense of class consciousness and often have little or no love for the neighbourhood in which they live.[45] In my own research with drug-using panhandlers, anti-neighbourhood sentiments appear near universal, as are expressions of dislike and distrust for other panhandlers. I cannot recall a single expression of solidarity with other panhandlers from the people I have spoken with, and I vividly recall the day a panhandler told me that the best thing that could happen to the neighbourhood (where he had lived for over a decade) would be if it all "burned to the ground." Panhandling drug users who are either homeless or inadequately housed represent a segment of the Downtown Eastside so marginalized that the neighbourhood appears to offer no sense of meaningful emotional attachment; for them, it is simply a place of pain and humiliation.

It is important not to draw too much from emotionally-charged statements like these. At the risk of levelling charges of "false consciousness" against these panhandlers, there is certainly much about the neighbourhood that they would miss if it were gone. The Carnegie Community Action Project's (CCAP) recent *Community Vision for Change*

44 Sommers, "Men at the Margin," 302-303. For more on Marx and Engel's discussion of the *lumpen,* see Hal Draper, "The Concept of the 'Lumpenproletariat' in Marx and Engels," in *Economies et Sociétés* 6 no. 12 (1972), 2285-2312; and Peter Hayes, "Utopia and the Lumpenproletariat: Marx's Reasoning in *The Eighteenth Brumaire of Louis Bonaparte,*" in *The Review of Politics* 50 no. 3 (1988), 445-465 .

45 There are, nevertheless, groups doing remarkable work trying to produce just such a sense of class (or group) conscious-ness. First amongst these is the Vancouver Area Network of Drug Users (VANDU) who have created a very powerful sense of shared identity for their 1,500-plus members and who mobilize this identity to fight for their interests as drug users.

featured a questionnaire conducted with 655 low-income residents and claimed that ninety-five percent of respondents would prefer to remain in the neighbourhood—*if* they had safe and secure housing.[46] At the same time, a 2008 demographic survey of the neighbourhood found that only sixteen percent of the SRO residents they interviewed wanted to remain in the Downtown Eastside.[47] Martha Lewis, the study's lead author, warned against drawing overly hasty conclusions from this statistic because it did not account for people's desire to remain in the neighbourhood if their most pressing complaints were addressed.[48] These caveats are important in as politically charged a climate as this one, where suggestions that residents do not like their neighbourhood can be used by property-developers and politicians as justification for gentrification.[49]

The CCAP's *Community Vision* is explicit that the Downtown Eastside possesses qualities that residents desire. Foremost among these is the sense of acceptance and "sanctuary" people feel in the community.[50] Indeed, the Downtown Eastside is a place where many marginalized people are accepted, are not stigmatized for their addictions, and are perhaps also spared the prejudice they encounter in the rest of the city. Nevertheless, these benefits are apparently not experienced by all, as the example from the panhandlers and drug users I refer to above suggests. If part of achieving political change depends on the successful creation of a class or group identity—that is, of individuals recognizing that their personal problems are shared by others and can be solved through common struggle—then the continued feeling of exclusion expressed by these *lumpen* subjects suggests that they have not felt themselves hailed by contemporary progressive discourse.

In light of the demographic transition in the Downtown Eastside from the retired resource worker to the more marginalized *lumpen* population of today, it is telling that

46 Wendy Pedersen and Jean Swanson, *Assets to Action: Community Vision for Change in the Downtown Eastside* (Vancouver: Carnegie Community Action Project, 2010), 6.

47 Martha Lewis, et al, *Downtown Eastside Demographic Study of SRO and Social Housing Tenants*, (Vancouver: City of Vancouver, 2008), 23.

48 In a separate question, nearly half (forty-eight percent) rated their satisfaction with the neighbourhood as "poor" or "very poor" as reported in Lewis, *Downtown Eastside Demographic Study*, 33.

49 This concern was precisely what prompted the study's authors to include the caveats mentioned above. See Martha Lewis's comments in Condon, Sean, "Sobering Statistics: Downtown Eastside Survey Paints Grim Picture," the *Dominion* (August 25, 2008), http://www.dominionpaper.ca/articles/1996.

50 Pedersen and Swanson, in *Assets to Action*, 10.

DERA is no longer the hegemonic political voice in the neighbourhood. Arguably, since the late 1990s, it has been the Portland Hotel Society (PHS) that has advanced the dominant articulation of the neighbourhood, its problems, and the appropriate solutions.

The PHS was initially a product of DERA, which purchased the Pennsylvania Hotel at Hastings and Carrall, intending to renovate it in order to provide housing for people with concurrent disorders.[51] The PHS took over control of the building in 1993 and today operates thirteen residences for the hard-to-house, along with the Insite supervised injection site, Washington needle depot, and even a bank for residents who cannot access conventional financial services.[52] The scope of the PHS's activities in the neighbourhood cannot be overemphasized; over the past fifteen years, they have become by far the most dominant group in the Downtown Eastside, commanding significant amounts of government funding for the neighbourhood and becoming BC Housing's de facto provider of services for the hard-to-house.

There is much to be inspired by in the PHS's ethics. Staff members treat residents with respect and generosity, and they do not pass judgment on the lives they live, even when they involve sex work, active drug addictions, crime to feed addictions, and disruptive behaviours related to past trauma. Whether in the hotels or at the supervised injection site, they endeavour to support and house an extremely challenging—indeed, *lumpen*—population and have been incredibly successful in doing so.[53]

There is a great deal that is different about the PHS from their forebears in DERA. If there is a righteous anger at the centre of any political group, in the PHS, it concerns the violence of the bourgeois dichotomy between the deserving and undeserving poor, between working class and *lumpen*:

> I think in the past, the Downtown Eastside got a lot from this notion of the bearded white loggers that built the wealth of the province. But I don't know if that was true or false … but, the older activists were very successful in pushing that kind of version of what was going on down here. And, because of that, lots of housing got built. But, nowadays, the cracks in that image start to

51 A concurrent disorder describes a situation where a person experiences both a mental health issue, such as schizophrenia or clinical depression, as well as a substance abuse problem.
52 Portland Hotel Society, *PHS Overview*. Fact-sheet published by the Portland Hotel Society, n.d. The PHS also runs an art gallery, "life skills" centre, café, and free medical/dental clinic.
53 Residents of the PHS are the epitome of the sort of *lumpen* subjects I am describing.
 Penny Gurstein and Dan Small provide this statistical picture of the residents: "Most have limited education, and have not completed high school. Thirty-five percent have had some form of childhood trauma, most often physical and/or sexual abuse. Thirty-four percent have a diagnosed mental illness. Thirty-three per cent are HIV positive or have AIDS that they most likely got from injection drug use. Twenty-five percent have Hepatitis C. Eighty-eight percent have a drug or alcohol addiction and seventy-three percent are injection drug users. Ninety percent have been involved in the criminal justice system. All are well below the poverty level." Penny Gurstein and Dan Small, "From Housing to Home: Reflexive Management for those Deemed Hard to House," in *Housing Studies* 20 no. 5 (2003), 725.

get revealed. That it's more complicated. There are mainly people down here who wider society sees as undeserving. That we don't have to worry about, and we don't have to provide a house and a roof and a bit of food. That really they should be punished for the sort of people they are.[54]

The PHS positions itself as a progressive group carrying on the legacy of defending the rights of Downtown Eastsiders but frames their work *against* the representational strategies employed by the generation before. Whereas DERA challenged the 1950s discourse of skid row with one of working-class community, the PHS points to the exclusions which were produced in the process of reifying the figure of the "bearded white logger."

In light of the changing demographics of the Downtown Eastside, as well as the fundamental political necessity of including the *lumpen* in any legitimate political project, the critique represented by the PHS is an essential component to the political discourse of the Downtown Eastside. This does not mean that the PHS as a whole is an answer to the neighbourhood's need for an organization that can represent it and deliver change. Indeed, unlike DERA, the PHS is not a democratically run organization, and thus is not accountable to its residents in the way DERA was accountable to its members. And while much of what the PHS does is politically very progressive, it is not an organization dedicated to building political solidarity and class identity in the way that DERA was. If DERA presented an image of the retired resource worker as a counterpoint to the skid row derelict, who does the PHS offer as a political figure? So far, that figure has been the "hard-to-house" and the resident with "concurrent disorders." This has meant that the discourse offered by the PHS in replacing DERA's "working class community" is one of "human rights" and perhaps "best practices" in the management of difficult populations—an important *humanitarian* discourse perhaps, but not the sort of radical *political* discourse the neighbourhood requires. This work of building a class identity has fallen to other groups in recent years: the Carnegie Community Action Project (CCAP), Downtown Eastside Neighbourhood Council (DNC), and Vancouver Area Network of Drug Users (VANDU) most notably. We can see in these groups the continuation of a legacy of democratic, citizen-led organizing for which the Downtown Eastside is justly famed. More importantly perhaps, while these groups share much with the rhetoric of community solidarity advanced by DERA, the conception of community they advance is not one predicated

54 Co-executive director of the PHS (not named), quoted in Gurstein and Small, "From Housing to Home," 723.

on the exclusion of a *lumpen* other. Indeed, the interests of drug users, panhandlers, and binners feature prominently in the CCAP's recent *Community Vision for Change* through recommendations for a regulated legal drug market, as well as rights for those who make their living through binning at the weekly street markets organized by the DNC. The work done by these groups is vital if the Downtown Eastside is to remain a politically active community and create a new political subject that includes the *lumpen* who were previously excluded. As important as the work done by the PHS has been to sustaining the lives of this group, it does not appear that they will be the ones producing such a political subject. Nevertheless, they continue to be the organization advancing the dominant narrative of the neighbourhood, as well as the group through which substantial state monies enter the neighbourhood for housing and health care. It remains to be seen whether other, more political—and at the same time, more inclusive—narratives can rise to prominence, allowing the Downtown Eastside to speak in a voice more fully its own.

Bussard, Robert. "The 'Dangerous Class' of Marx and Engels: The Rise of the Idea of the *Lumpenproletariat.*" *History of European Ideas* 8, no. 6, (1987), 675–692.

Campbell, Larry, Neil Boyd, and Lori Culbert. *A Thousand Dreams: Vancouver's Downtown Eastside and the Fight for its Future.* Vancouver: Greystone Books, 2009.

Canning-Dew, J. *Hastings and Main: Stories from an Inner City Neighbourhood.* Vancouver: New Star Books, 1987.

City of Vancouver. *Downtown Eastside: Building a Common Future, Report #1 for Council Consideration.* Vancouver: Planning Department of Vancouver, 1998.

City of Vancouver. *2005/06 Downtown Eastside Community Monitoring Report.* Vancouver: Central Area Planning Department, 2006.

Condon, Sean. "Sobering Statistics: Downtown Eastside Survey Paints Grim Picture." The *Dominion* (August 25, 2008), http://www.dominionpaper.ca/articles/1996.

Draper, Hal. "The Concept of the 'Lumpenproletariat' in Marx and Engels." *Economies et Sociétés* 6, no. 12 (1972), 2285–2312.

Gurstein, Penny and Dan Small. "From Housing to Home: Reflexive Management for those Deemed Hard to House." *Housing Studies* 20, no. 5 (2003), 717–735.

Hassan, Schlomo and David Ley. "The Downtown Eastside: 100 Years of Struggle." In *Neighbourhood Organizations and the Welfare State*, eds. Schlomo Hassan and David Ley, 172–204. Toronto: University of Toronto Press, 1994.

Hayes, Peter. "Utopia and the Lumpenproletariat: Marx's Reasoning in *The Eighteenth Brumaire of Louis Bonaparte.*" *The Review of Politics* 50, no. 3 (1988), 445–465.

Knight, Rolf. *Along the No. 20 Line: Reminiscences of the Vancouver Waterfront.* Vancouver: New Star Books, 1980.

Lewis, Martha, Kathleen Boyes, Dale McClanaghan, and Jason Copas. *Downtown Eastside Demographic Study of SRO and Social Housing Tenants.* Vancouver: City of Vancouver, 2008.

Ley, David. *The New Middle Class and the Remaking of the Central City.* Oxford: Oxford University Press, 1996.

Marion-Young, Iris. *Justice and the Politics of Difference.* Princeton, NJ: Princeton University Press, 1990.

Marlatt, Daphne and Carole Itter. *Opening Doors in Vancouver's East End.* Madeira Park, BC: Harbour Publishing, 2011. (First published as *Sound Heritage*, VIII, no. 1 and 2, Victoria, BC: Aural History Program, Ministry of Provincial Secretary and Government Services, 1979.)

Marx, Karl and Friedrich Engels. *The Communist Manifesto.* Translated by Samuel Moore. Harmondsworth, UK: Penguin Books, 1967.

Marx, Karl. *The Eighteenth Brumaire of Louis Bonaparte.* Translated by D.D.L. New York: Mondial, 2005.

Millar, John S. *HIV, Hepatitis, and Injection Drug Use in British Columbia: Pay Now or Pay Later?* Victoria, BC: Office of the Provincial Health Officer, BC Ministry of Health, 1998.

Olds, Kris. "Urban Mega-Events, Evictions and Housing Rights: The Canadian Case." *Current Issues in Tourism* 1, no. 1 (1998), 2–46.

Pedersen, Wendy and Jean Swanson. *Assets to Action: Community Vision for Change in Vancouver's Downtown Eastside.* Vancouver: Carnegie Community Action Project, 2010.

Portland Hotel Society. *PHS Overview.* Fact sheet, n.d.

Smith, Heather. "Planning, Policy and Polarisation in Vancouver's Downtown Eastside." *Tijdscrift voor Economiche en Sociale Geografie* 94, no. 4 (2003), 496–509.

Sommers, Jeff. "Men at the Margin: Masculinity and Space in Downtown Vancouver, 1950-1986." *Urban Geography* 19, no. 4 (1998), 287–310.

Sommers, Jeff and Nick Blomley. "The Worst Block in Vancouver." In *Stan Douglas: Every Building on 100 West Hastings*, ed. Reid Shier, 18–58. Vancouver: Arsenal Pulp Press and Contemporary Art Gallery, 2002.

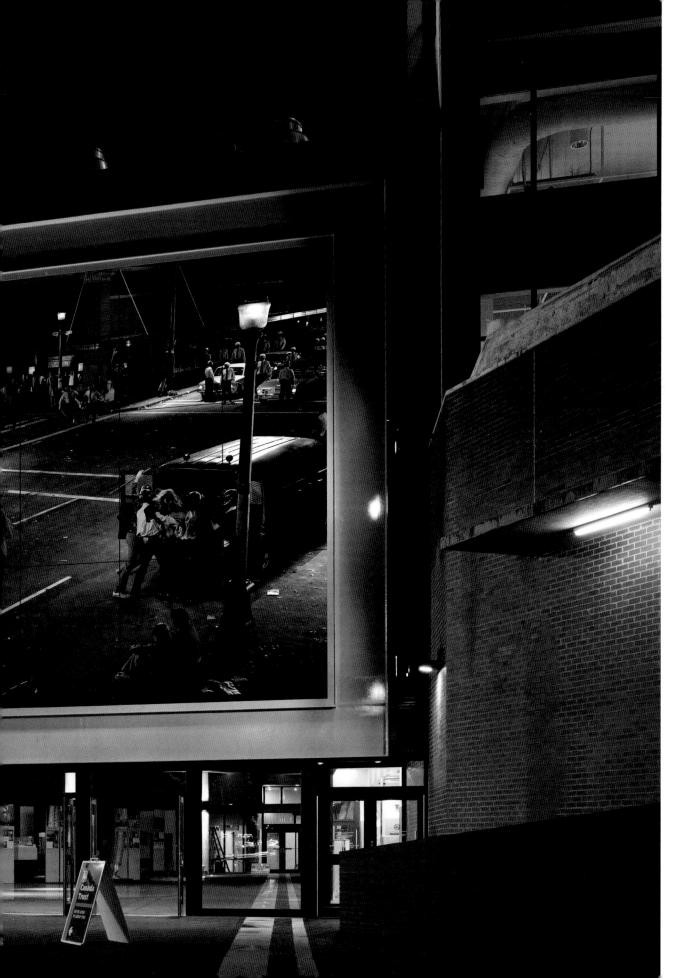

INDEX

STAN DOUGLAS is a visual artist who lives and works in Vancouver. His films, videos, and photographs have been seen in exhibitions internationally, including Documentas IX, X, and XI (1992, 1997, 2002) and three Venice Biennales (1990, 2001, 2005). A comprehensive survey of his work, *Past Imperfect: Works 1986–2007*, was mounted by the Württembergischer Kunstverein and the Staatsgalerie Stuttgart in the fall of 2007. Between 2004 and 2006 he was a professor at Universität der Künste Berlin and since 2009 has been a member of the core faculty in the Grad Art Department of Art Center College of Design in Pasadena.

ALEXANDER ALBERRO is the Virginia Blodel Wright Professor of Art History at Barnard College, Columbia University. He is the author of *Conceptual Art and the Politics of Publicity* (MIT Press, 2003), the co-author of *Art After Conceptual Art* (MIT Press, 2006), and the co-editor of *Conceptual Art: A Critical Anthology* (MIT Press, 1999) and *Institutional Critique: An Anthology of Artists' Writings* (MIT Press, 2009), He lives in New York and Philadelphia.

NORA M. ALTER is a professor of film and media arts at Temple University, Philadelphia. She is the author of *Vietnam Protest Theatre: The Television War on Stage* (Indiana University Press, 1996), *Projecting History: German Nonfiction Cinema, 1967-2000* (University of Michigan Press, 2002), and *Chris Marker* (Contemporary Film Directors) (University of Illinois Press, 2006), and the co-editor of *Sound Matters: Essays on the Acoustics of German* Culture (Berghan, 2004).

SERGE GUILBAUT is a professor of art history at the University of British Columbia. He received his PhD in Art History from UCLA in 1979. His books include *How New York Stole the Idea of Modern Art* (University of Chicago Press, 1983), *Voir, Ne pas Voir, Faut Voir* (Chambon, France, 1993), *Sobre la desaparición de ciertas obras de arte* (Curare/Fonca, Mexico, 1995), and *Los Espejismos de la imagen en los lindes del siglo XXI* (Akal Ediciones, Spain, 2009). He lives in Vancouver.

SVEN LÜTTICKEN is a professor of art history at Vrije Universiteit, Amsterdam. His books include *Idols of the Market Modern Iconoclasm and the Fundamentalist Spectacle* (Sternberg Press, 2008) and *Secret Publicity: Essays on Contemporary Art* (NAi Publishers, 2006). He was the first laureate of the Netherlands Foundation for Visual Arts, Design and Architecture's Prize for Art Criticism.

JESSE PROUDFOOT is a PhD candidate at Simon Fraser University's Department of Geography, and a post-doctoral researcher at DePaul University, Chicago (Fall 2011). He is a specialist on the urban geography of Vancouver's Downtown Eastside neighbourhood.

ABBOTT & CORDOVA PRODUCTION CREDITS

CAST

CREW

Bystanders:
Robson Baker
Stefan Busse
Tina Carey
Vincent Cheng
Shelby Chapman
Michelle Cowley
Shraga Dachner
Luciana D'Arunciasco
Bill Dekker
Anthony Dodd
Andrew Dorocilz
Brad Dutchak
Emily Emond
Ted Garbutt
Bill Orlikow
Ian Pawsey
Monica Richards
Lorne Riding
Charanjit Singh
Wolf Suhl
Ken Wa

Constables
Waynos Allum
Dave Antolinos
Currie Auld
Samuel Barnes
Scott Davis
Colin Fotherby
Nick Haltigin
Kary Hansen
Mike McBean
Royal Munro
Randy Noel

Hippies
Jacqueline Adamson
Michael Bardach
Donald Berry
Karim Biamonte
Samantha Clyne
Rob Compton
Jolene Derksen
Gary Ellison
Vladimir Fedulov
Andrew Ghisleri
Megan Gilron
Justin Gough
Lucky Gule
Blythe Hutchings
Zandara Kennedy
Simon Kral
Jamie MacLeod
Christine McMahon
John Morrison
Madeleine Myrhoj
Greg Ng
Marisa Nielsen
Veronica Papalia
Michael Prosser
Walker Suddaby
Wyatt Suddaby
Tristan Tyner
Jason Vaisvilla
Clay Virtue
Stuart Wallin
Chris Webber
JC Williams
Eli Zagoudakis
Jenny Zinger

Mounted Police
Mike Garthwaite
Kerry Hansen
Quinton Schneider

Narcs
Lee Clarke
Brent Dawes
James Gorman
Graham Huber
Gabriel McLaren
Ethan Rush

Production Designer,
Photographer, Editor
Stan Douglas

Producers
Arvi Liimatainen
Heather Howe

Studio Manager
Linda Chinfen

Assistant Director
Lee Knippelberg

2nd Assistant Director
William "Big Sleeps" Stewart

Camera Assistant
Henri Robideau

Gaffer
Sean Rooney

Best Boy
Tony Richarson

Genny Operator
Hugh Miekle

Lamp Operators
Mark Alexander
Scott Clark
Collin Hillis
Christian Schauz

Condor/Lamp Ops
Jacob Egglestone
Darryl Laval
Joern Schultke
Leonard Taylor

Set Wireman
Warren Bruce

Key Grips
Miguel Gelinas
Rob Sperling
Jayson Rupert

Grips
Dan Basaraba
Troy Bassett
Jeff Bonny
Mike Fiedler
Jake Humphrey
Ryan Ketchum
Adrian R. Netto
Kyle Ruiterman

Casting
Lisa Ratke

Extras Wranglers
Ntsikie Kheswa
Stephen Eathorne
Carol Korm

Set Decorator
Melissa Morden

Assistant Set Decorator
Jacquie Rae Mason

Set Dresser
Tim Higgins

On Set Dresser
Todd Keller

Buyers/Dressers
Mark MacPhee
Joanne Morden
Ian Nothnagel
Judy Stackaruck

Props Master
Dave Fleisher

Props Assistants
Jordan Fleisher
Charles Newson

Costume Designer
Sheila White

Assistant Costume Designer
Patty Hunter

MURAL

Costumers
Daevina Danyluck
Kai Siperko
Lyne Talbot

Stunt Coordinator
Danny Virtue

Assistant Stunt Coordinator
Eli Zagoudakis

Horse Wranglers
Mike Garthwaite
Kerry Hansen
Quinton Schneider
Lani Terada

Special Effects Coordinator
Darcy Davis

Construction Coordinator
Jesse Joslin

Foreman
Keith McCulloch

Lead Carpenters
Geoff Jordan
Barry Rennie

Scenic Carpenters
Adam Barlett
Joshua Cockerham
Rolfe Fuhrmann
Clive Joslin

Carpenters
Dan Brodie
Luke Victor

Construction
Chris Fielden

Lead Sculptor
Robert Houtman

Paint Coordinator
John Wilcox

Painters
Brad Lambert
Randy MacKenzie
Michael Sullivan

Scenic Artists
Thomas A. McKinnon
Thomas Wren

Greens
John McIntosh

Hair
Sarah Bergeest
Heather McLellan
Lisa Waddell

Make-Up
Leslie Graham
Tana Lynn Moldovanos
Tamar Ouziel

Unit Manager
Rob Murdoch

Production Coordinator
Anja Liimatainen

Production Assistant
Sean Arden

Accountant
Patrick Mokrane

Researcher
Faith Moosang

Clearance Coordinator
Terri Garbutt

3d Modelling
Murray Gilmore

Graphic Designer
Catherine Schroer

3d Consultant
Tada Rivola

Compositor
Gordon Oscar, Artifex Studios

Location Manager
Alan Bartolic

Assistant Location Manager
Charles Kittson

Location PAs
Lynn Chick
Dezmond Haddock
Monty Hill
Nick Ismirniooglou
Mike Macree
Jennifer Rowlands
Dave Watt

Stills
Linda Chinfen
Rosamond Norbury

Caterer
First Take Catering

Chef
Soren Tambour

Assistant Chefs
John Michael
Lisa Rowson
David Neil

First Aid / Craft Service
Shoana Harrower
Laura Lulu Lund

Crafty Assistants
Bianca Felderer
Brianna Lawrence

Security Captain
Than Hadjioannou

Police Liaison
Cst. Michele Hannah

Drivers
Paul Parent
Chuck Greig
John Dryden

Executive Producer
Ian Gillespie, Westbank
Projects / W Redevelopment
Group

Architects
Gregory Henriquez & Peter
Wood, Henriquez Partners
Architects

Glass Fabrication
& Installation
Steve Lebedovich, Phoenix
Glass

Printing
Darren Eaton,
Multigraphics Ltd.

ARSENAL PULP PRESS
#101–211 East Georgia Street
Vancouver, BC V6A 1Z6
Canada
arsenalpulp.com

The publisher gratefully acknowledges the support of the Canada
Council for the Arts and the British Columbia Arts Council for
its publishing program, and the Government of Canada (through
the Canada Book Fund) and the Government of British Columbia
(through the Book Publishing Tax Credit Program) for its publishing
activities.

The publisher wishes to thank the following for their assistance
with this book: Grant Arnold; Glenn Baglo; Linda Chinfen; the
City of Vancouver Archives; Rosamond Norbury; Colin Preston, CBC
Vancouver Media Archives; Sarah Romkey, UBC Library, Rare and
Special Collections; Neil Wedman; David Zwirner; and Stan Douglas.

Unless otherwise indicated, photos of Stan Douglas's works and
installations were provided courtesy of the artist and David Zwirner,
New York.

Efforts have been made to locate copyright holders of source
material wherever possible. The publisher welcomes hearing from
any copyright holders of material used in this book who have not
been contacted.

Design by Steedman Design
Project coordination by Robert Ballantyne
Editing by Brian Lam and Robert Ballantyne
Printed and bound in Korea

Library and Archives Canada Cataloguing in Publication:
Douglas, Stan
 Stan Douglas : Abbott & Cordova, 7 August 1971.

Includes index.
Issued also in electronic format.
ISBN 978-1-55152-413-9

 1. Douglas, Stan. Abbott & Cordova, 7 August 1971.
I. Title. II. Title: Abbott & Cordova, 7 August 1971.

N6549.D68A62 2011 779'.997113304 C2011-903759-9